THE LIMITS OF ART

TZVETAN TODOROV

THE LIMITS OF ART
TWO ESSAYS

TRANSLATED BY GILA WALKER

Seagull
BOOKS

LONDON NEW YORK CALCUTTA

Seagull Books 2010

Original text © Tzvetan Todorov 2010
English translation © Gila Walker 2010

ISBN 978 1 9064 9 762 0

British Library Cataloguing-in-Publication Data
A catalogue record for this book is available from the British Library

Typeset by Seagull Books, Calcutta, India
Printed at Trio Process, Calcutta, India

CONTENTS

ARTISTS AND DICTATORS

For what is merit in a writer is sometimes vice in a statesman, and the same things which have often made lovely books can lead to great revolutions.

—Alexis de Tocqueville[1]

THE TOTAL WORK OF ART·

Since the age of Romanticism, art has been granted more importance than ever before. It has been regarded as a higher mode of achieving knowledge than science, and as embodying, in the place of religion, the highest activity to which human beings

This essay is a much revised and augmented version of an earlier article by Tzvetan Todorov, 'Avant-gardes and Totalitarianism' (Arthur Goldhammer trans.), published in *Daedalus* 136(1) (Winter 2007): 51–66. Reprinted by permission of the author.

1 Alexis de Tocqueville, *The Old Regime and the Revolution* (François Furet and Françoise Mélonio eds; Alan S. Kahan trans.) (Chicago: University of Chicago Press, 1998), p. 201.

3

can devote themselves. Paul Bénichou has termed this shift in attitude 'the consecration of the writer'[2], which could be extended to apply to artists in general. 'Beauty in its absolute essence is God,'[3] declared a proponent of Romanticism. As specialists of Beauty, artists were its most devoted servants and poets its prophets. The fact that the Romantics considered art and poetry exemplary manifestations of the beautiful did not, however, imply indifference to other human activities. In the late eighteenth century, for Friedrich Schiller, author of *On the Aesthetic Education of Man* (1794), as for his successors, an aesthetic education culminates in a political project: the human condition could only be improved by joining the two spheres of activity.

One of the most influential expressions of this aspiration can be found in the writings of Richard Wagner. Inspired by Mikhail Bakunin's revolutionary ideals, Wagner took part in the political agitation in Dresden in 1848–49. Forced into exile after its repression, he found refuge in Switzerland, where, in 1849, he published two essays propounding his ideas on art and its relationship to society: *Art and Revolution* and *The Artwork of the Future*. Wagner aspired to the absolute but did not seek it in established religions. He saw art as the greatest embodiment

2 Paul Bénichou, *The Consecration of the Writer, 1750–1830* (Mark Jensen trans.) (Lincoln and London: University of Nebraska Press, 1999).

3 Rodolphe Töpffer, *Réflexions et menus propos d'un peintre genevois* (Thoughts and minor comments of a Genevese painter), VOL. 2 (Paris: Jacques-Julien Dubochet, 1848), p. 60. I have described this process at length in my book *Les aventuriers de l'absolu* (The adventurers of the absolute) (Paris: Robert Laffont, 2006).

of absolute values: 'The Art-work is the living presentation of Religion.'[4] This being the case, Wagner suggested that a two-way relationship be established between artistic activity and social life.

For art to thrive, society would have to provide it with the most favourable conditions possible. And since the world in which Wagner lived—as constituted by the Germanic states of his day—was far from offering such conditions, it had to be transformed, and this transformation would be accomplished by means of revolution. Thus, Wagner was interested in politics only insofar as it contributed to the blossoming of art. Social revolution was not so much an end in itself as it was a means of bringing about an artistic revolution—the foundation upon which to build a new edifice.

Why confer such an honour upon artists? This is where the second part of the relationship between art and society enters the picture. 'Art is the highest expression of activity of a race,'[5] that which crowns its existence on earth, and 'True Art is highest freedom,'[6] Wagner declared. The composer shared the dream of the Saint-Simonians, who believed that, one day, machines would relieve men of their most taxing toils and that, having cast off these exhausting chores, men would turn their attention to artistic creation, with freedom and joy. Art need not be

4 Richard Wagner, *Prose Works*, VOL. 1 (William Ashton Ellis trans.) (New York: Broude Bros, 1966 [1898]), p. 91.

5 Ibid., p. 38.

6 Ibid., p. 35.

pitted against life, as another version of the Romantic doctrine
maintained, for art was life's crowning accomplishment. 'Artistic
manhood' was synonymous with 'the free dignity of Man'.7 As
labour became art, proletarians would become artists and slaves
of industry would become makers of beauty. The society of the
future would no longer be in the service of art, as Wagner sug-
gested earlier, since all lives would have become artistic. Art
would become the ideal model of society. There would be no
cause to celebrate artists because everyone would be an artist.
Or, to be more precise, the community as a whole, freely decid-
ing how it would live, would adopt the attitude of the creator.
'Who, then, will be the Artist of the Future? The poet? The per-
former? The musician? The plastician?—Let us say it in one
word: the Folk [meaning "the people"].'8 It was because only a
common effort could achieve this project that Wagner opted for
what he considered the opposite of selfishness—namely,
Communism, whose manifesto was published the year before by
Karl Marx and Friedrich Engels.

The failure of the revolutions of 1848 in Europe sounded
the death knell of such dreams. Then came the beginning of the
second great period in the history of the earthly absolute, from
1848 to the First World War, during which time the two paths—
the collective and the individual, the political and the aesthetic
—grew dissociated. For Charles Baudelaire, an enthusiastic

7 Ibid., p. 56.

8 Ibid., p. 47.

commentator on Wagner, the hope of seeing art influence the world was an illusion. Marx, on the other hand, was unconcerned with the aesthetic education of individuals. The two paths were fabulously indifferent to each other, yet neither imagined relinquishing its superiority over the other. Things changed again in the twentieth century, and this is the moment in history that I will be examining more closely hereafter. The movement that emerged at that point in time was twofold, but in each case it can be described as an actualization of the Wagnerian project to create a total work of art—corresponding in extent with the whole of life and the entire world.

On the one hand, a few particularly radical art movements saw themselves as the embodiment of the avant-garde, adopting the military metaphor that had widespread currency in the political vocabulary of their day. Several characteristics distinguished these avant-garde movements from earlier art movements like Naturalism, Impressionism or Symbolism, which had already regarded innovation as compulsory. For one, these movements did not content themselves with novelty. Then, they advocated a radical break with the past, consigning to oblivion all those who had come before them, for they thought that their own art rendered all others' obsolete. And, having given themselves such a sublime purpose, they considered that all means of achieving their ends were good, especially the more radical ones. Theirs, then, was a call for revolution. Finally, they were intent

on broadening the field of artistic intervention to encompass the whole of social and political life.

On the other hand, several years later, extremist political movements, in an apparently independent development, framed their own projects for transforming society and people, modelled on the paradigm of artistic creativity. This was the case for Communism, Fascism and Nazism. The idea of the avant-garde was present here too, but it was embodied in a party rather than in the work of a few talented artists. It was the task of these parties (Communist, Fascist, and National Socialist) to lead the passive masses.

In both cases, revolutionary violence was seen as an appropriate means to hasten the achievement of goals. Activists knew they were promoting a change so radical that it risked meeting resistance and that this resistance would have to be eliminated—if need be, by force. The relationship between these two movements did not simply consist in the usual proximity between art and power, with each using the other as a means: political powers employing art for propaganda and to create captivating settings for political meetings, and artists employing political themes to make their art more appealing. In this case, the two practices discovered that the bonds between them ran deeper than mere contiguity, and they tended to imitate each other. This twofold movement of convergence between the two major forms of the earthly absolute—the political and the artistic—

developed in Russia, Italy, and Germany. There are a number of lessons that can be learned from this.

Italian Futurism

Europe was going through a period of change at the beginning of the twentieth century that we have trouble grasping today because of the exceedingly rapid pace of transformation since. But let us imagine for a moment what it must have been like to see for city dwellers to see their habits turned upside down. Electric power had just been harnessed and was becoming part of everyday life for millions of people. New easier-to-use energy sources, such as gas and fuel, were becoming familiar. With the first airplanes, the age-old dream of leaving the surface of the Earth and flying had come true. Private motor vehicles were taking to roads everywhere. The industrial revolution was radically changing everyone's life and seemed to have opened an era of inventions that was not about to stop. For the first time in the history of the Western world (Western Europe and North America), people had the impression that innovation was triumphing over tradition and that works of human design counted more than natural phenomena. It seemed as if the Cartesian project of man becoming the master and possessor of nature was about to be accomplished.

Artists in societies everywhere, and in particular poets and painters, are never content with producing works to meet

standards of beauty. They perhaps form the part of the population that is most sensitive to the pulse of their times, most able to perceive trends of which other people are as yet unaware even as they illustrate them by their behaviour. This time too, artists were the first to capture the social and mental transformations caused by the extraordinary advances in technology. Italian Futurism was the first avant-garde art movement to embark on this course and it became a model for the movements that followed thereafter.

Filippo Tommaso Marinetti, its founder and leader, cut an altogether untraditional figure as an artist. He demonstrated no great talent as a novelist, playwright or poet and no great originality as a thinker. But as an activist he was remarkably gifted. The circumstances around the launch of his first manifesto are telling in this regard. Marinetti filled his text with provocative statements intended to 'shock the bourgeois' and sent it off to the Italian press. Unfortunately for him, it arrived at the same time as news of the deadly earthquake in Messina in December 1908; and so, this manifesto, signed by an unknown author, was relegated to the back pages of the papers and went unnoticed. Since Marinetti's work could not exist without an echo from the public, he decided to send the manifesto to the French press. This in itself demonstrates the growing internationalization of cultural life of that time—one of the effects of the rapid technological transformation of the planet. The first 'Manifesto of

Futurism' was published in *Le Figaro* on 20 February 1909 and caused a sensation.

The manifesto glorified modern life, big cities, and speed. These were common themes with other authors, which Marinetti managed to synthesize and hyperbolize, and reduce to a series of slogans. What made him particularly original was that he situated these themes in the wider context of a plea to eliminate any reference to the past and to celebrate the cult of novelty. The places that preserved the memory of the past did not deserve to exist: 'Heap up the fire to the shelves of the libraries! Divert the canals to flood the cellars of the museums! [. . .] Undermine the foundation of venerable towns!'[9] Only after having integrally destroyed everything that existed could construction begin anew. The manifesto also revealed Marinetti's penchant for the Nietzschean superman that was to play a central role in his work. He extolled power, aggression, fighting, war ('the world's only hygiene'), virility (leading to 'contempt for woman') and injustice—all slogans that had the virtue of drawing attention to himself.

In this first manifesto, Marinetti made no direct mention of 'futurist' activity outside the field of art. But it was clear that his approach concerned the whole of social life and he himself would soon go down this road (though not all the artists and poets who joined his movement did so). That very year, on the

9 See: cscs.umich.edu/~crshalizi/T4PM/futurist-manifesto.html

occasion of the 1909 general elections, he issued his *Political Manifesto for Futurist Voters* with directives to fight clericalism and attachment to the past, and to uphold patriotism and Italy's wars of conquest. Other tracts and proclamations from the same period, inspired by the revolutionary syndicalism theorized by Georges Sorel, called on artists and proletarians—'the most extreme wings of politics and literature'—to join forces. Marinetti publicly backed Italy's war in Libya in 1912 in numerous articles. 'The word *Italy* should prevail over the word *freedom*,'[10] he stated, in an expression of the growing importance of patriotism in his thinking. Concomitantly, Futurism was spreading to new areas: not only painting, music, theatre and music hall, but also architecture, objects of everyday life, design and habits.

In 1911, Marinetti published (in French again) his collected oral and written texts under the title *Le Futurisme*, which was soon translated into several languages. He reiterated his attachment to what he termed 'the absolute principle of Futurism', by which he meant 'the ongoing physiological and intellectual development and endless progress of man'. This was clearly a project to transform human beings and not only the arts, and it concerned as much the body as the mind. Marinetti declared war to be 'the world's only hygiene' and the struggle against the enemy ('the eternal enemy that we would have to invent if he

10 Giovanni Lista (ed.), *Marinetti et le futurisme* (Marinetti and Futurism) (Lausanne: L'âge d'homme, 1977), pp. 18, 19.

didn't exist') a necessity. In another chapter, he developed arguments to support his contempt for women: his disdain was for the values they embodied—love, affection, and sensuality—and their excessive closeness to nature. Women guaranteed the mere reproduction of the species through childbirth, whereas he aspired to the species' improvement, to the creation of 'a mechanical son, the fruit of pure will, a synthesis of all the laws that science is on the brink of discovering'. This new man— what he termed 'multiplied man'—would be mentally transformed: 'We look for the creation of a non-human type, in whom moral suffering, goodness of heart, affection and love [. . .] will be abolished,'[11] a true man of steel, mixed with iron and driven by electricity. Marinetti also pictured, somewhat prophetically, new technologies invading the world: chemical energy, a metal book of a hundred thousand pages, and a war between machines.

Throughout the First World War, Marinetti continued to defend nationalist and militaristic positions. In 1918, he became even more actively involved in politics when he released his *Manifesto of the Futurist Political Party* in which he developed his usual themes of anti-parliamentarianism, anti-clericalism, hostility to feminine values, equality of all before the law, social protection for the poor, and the need to replace the country's senior leaders with younger men. The following year, he joined

11 Filippo Tommaso Marinetti, *Le Futurisme* (Futurism) (Lausanne: L'âge d'homme, 1980), pp. 103, 110, 112, 159.

Benito Mussolini who had just founded the Fasci di Com-
battimento. The two men had known each other well since
1915, when they had held their first joint rallies. Mussolini
came from Socialist ranks and his movement had not yet broken
completely with leftist revolutionaries. This break came in 1920
and, as a result, Marinetti temporarily distanced himself
from Fascism and, in his writings, explained his disagreements
with political movements. In a pamphlet entitled *Beyond
Communism* (1920), he criticized its project of a classless paci-
fied society, which ran counter to the Futurist attachment to
ongoing war. His dispute with Fascism had to do with the rela-
tionship with the past: the alliance that Mussolini, as a shrewd
politician, had formed with conservative and clerical forces put
him at a distance from Futurist projects. But a short time later,
Marinetti was once again affiliated with the Fascist party. In
his pamphlet *Futurism and Fascism* (1924), he reasserted the ide-
ological proximity of the two movements, stating that 'Fascism's
coming to power achieved the minimum Futurist programme'[12]
and praising 'the futurist temperament of the President of
the Council', namely Mussolini. Despite differences of opinion
now and again, the poet and the politician remained friends
until the end.

12 Lista, *Marinetti et le futurisme*, pp. 59ff.

AVANT-GARDE MOVEMENTS IN GERMANY

The different avant-garde movements were very much in touch with one another. Marinetti put a lot of energy into spreading his ideas to other European countries. In Germany, such pre-First-World-War modernist movements as Die Brücke and Der Blaue Reiter, and more generally the Expressionist movement, advocated a radical break with earlier artistic traditions but did not aspire to change the world. Nevertheless, Futurism was well received, its impact conflated with that of other new groups (which explains Joseph Goebbels's later sympathy for it). The First World War caused a radical shift in attitude in Germany as well as in Russia and Italy. In this respect it played no less a decisive role in the direction taken by avant-garde movements than the advances in technology in the previous decades. The total war in which the European nations engaged turned out to be altogether different than the 'world's hygiene' as extolled by Marinetti. By the amount of destruction inflicted on the enemy, the systematic transgression of norms that had governed conflicts between 'civilized' countries until then, and the undermining of the very idea that humans had of their own identity, this war made feasible what had been inconceivable until then—the absolute abolition of the old society and its replacement by a new order. Advances in new technologies had had a similar impact but that had been a more gradual process. The effects of this war were more brutal because it was concentrated in a few short years and concerned not only the material aspects but the whole organization of social life.

The war had a particularly traumatic impact on countries where people were left with a sense of defeat or frustration. This was the case particularly in Germany, the biggest loser, and in Austria, the small country that emerged from the former vast empire. It was also the case in Russia—despite having fought on the side of the victorious allies—because it had been forced to sign an earlier separate peace that proved disastrous for it. And, appearances notwithstanding, it was the case in Italy as well, which had suffered defeats in the battlefields and had not received the territories promised to it when it entered the war. As it turned out, these were the three countries that experienced the most extensive development of avant-garde art movements on the one hand and the rise in revolutionary movements on the other that eventually lead to totalitarian regimes. Victorious France and Great Britain escaped this fate. Without the disaster of the First World War, Lenin would have remained a powerless exile, Mussolini an orator among others, and Hitler an agitator with no audience.

In Germany, a revolutionary movement brought an end to the monarchy immediately after the armistice. At the same time, in late 1918, an art movement called the November Group was formed, which counted among its members some of the foremost German artists of the day, particularly the Expressionists, including painters Max Pechstein and Emil Nolde, architects Mies van der Rohe and Walter Gropius, writers Bertolt Brecht

and Ernst Toller, musicians Alban Berg and Paul Hindemith. The group was enthusiastic about the Russian Revolution and hoped to see the same thing happen in Germany.

But history was to decide otherwise. The revolution was crushed in blood. The uprising organized by the (communist) Spartacists in early 1919 failed; its leaders Karl Liebknecht and Rosa Luxembourg were assassinated, and the liberal Weimar Republic was established. As the political revolution was in progress, so was a radical change in the arts. A 'workers' council for art' (or art soviet—the meaning of the word is the same) was founded and it was co-directed by Gropius. The council declared that 'Art and people must form a unity,' and that 'art shall no longer be the enjoyment of the few but the life and happiness of the masses.'[13] In certain respects, the project recalls Wagner's, 70 years before. Like Wagner, Gropius seems to have tried to compensate for the failure of the political revolution by starting an artistic movement (while in Russia, the victory of the former facilitated the progression of the arts for a while); and, like Wagner, Gropius dreamed of the unification of the arts, although not through opera but through architecture, which he saw as encompassing painting and sculpture.

13 Cited in Eric Michaud, 'L'œuvre d'art totale et le totalitarisme', in *L'œuvre d'art totale* (Paris: Gallimard, 2003), p. 43, whose analysis is followed in this essay. English translation can be found in Ulrich Conrads, *Programs and Manifestos on 20th-Century Architecture* (Cambridge, MA: MIT Press), p. 44.

Only a month after the inauguration of the Weimar Republic in 1919, the Bauhaus was founded. The same principles informing the workers' council undergirded the project of the group of architects and artists led by Gropius. The goal was not to conflate art with life but to create a total work of art, a complete building that 'will one day rise to heaven [. . .] like the crystal symbol of a new faith'. The building would resemble a cathedral more than anything else. Like the old religion, the new faith would need a temple—both would be embodiments of the aspiration to the absolute. But this project with religious overtones was not sustained for long. Bauhaus theorists could not disregard the fact that religious values had been brought down to earth. The temple of modern man was no longer a cathedral: 'Man has become God—his house is his church.'[14]

Gradually, the Bauhaus project drew closer to daily life. It was a matter not only of building houses for people but also of creating their everyday surroundings, from furniture and utensils to cities and landscapes. For this purpose, Bauhaus architects and artists had to know the 'people' for whom they worked. So, Gropius introduced courses in sociology—and even biology—into the curriculum. Surroundings had the power to transform and perfect the people living in them. So, artists could influence individual and collective ways of living by

14 *Bauhaus 1919–1969* (Paris: Musée national d'art moderne, 1969), p. 13, cited in Michaud, *L'œuvre d'art totale*, p. 47; See also *Anthologie du Bauhaus* (The Bauhaus Anthology) (Brussels: Didier Devillez, 1995), p. 110; Michaud, *L'œuvre d'art totale*, p. 53.

making everyday objects. But whereas Gropius retained some degree of political neutrality in his organization, after his departure in 1926, the pro-Communist movement began to grow, as did the tendency to bring all aspects of social life within the group's dominion.

The Russians and Germans maintained constant contact during the 1920s. Wassily Kandinsky began teaching at the Bauhaus in 1922. Russian artists came on very frequent visits to Berlin, where they gave lectures, organized exhibitions and published periodicals and books. El Lissitzky and Ilya Ehrenburg put out the journal *Veshch'* ('The Object') in Berlin, which became the forum for Constructivists. Kazimir Malevich organized an exposition there and had texts published by the Bauhaus. Hungarian artist Laszlo Moholy-Nagy, who came to Berlin in 1923, exerted an even more powerful influence, and his thinking was steeped in Constructivism. The goal, he declared in 1925, was not to create the Wagnerian total work of art, but, rather, to produce 'a synthesis of all aspects of life, which is itself a total work that embraces all things and transcends all separation'.[15] It was not to make art but to shape life. To build houses or cities was to organize vital processes and, in this way, artist-architects could fashion humankind. Once again, however, Constructivist aims ran up against political

15 Laszlo Moholy-Nagy, *Peinture, photographie, film* (Painting, photography, film) (Nîmes: J.Chambon, 1993), p. 78; Michaud, *L'œuvre d'art totale*, p. 54.

power. Like the Italian Futurists, who would have liked to see
Futurism become the official art but had to content themselves
with being a source of inspiration for Fascism, the founders of
the Bauhaus would not have been displeased to serve the archi-
tectural projects of the Nazis when they came to power in 1933
but they had to resign themselves to being bystanders as the
Nazis decided to produce their own 'total artwork'. The politi-
cal revolution required no assistance from revolutionary art.

The Bauhaus was not the only movement to associate inno-
vation in the field of art with the transformation of society. The
Dadaists in Berlin took up the banner of the Russian Revolution
in their 'Dada is German Bolshevism'16 declaration. New
Objectivity, an outgrowth of the Dadaist and Expressionist
movements, which included such artists as Georg Grosz, Otto
Dix and Max Beckmann, cultivated extremism in both politics
and art. As the influence of Nazi ideology intensified, avant-
garde artists had to make concessions, despite the goodwill of
some high-ranking Nazis such as Goebbels who liked to declare
his partiality to Expressionism as a specifically German style.
These artists, including those who proclaimed their loyalty to
Nazi ideology, were completely marginalized after 1933, and
even discouraged from expressing themselves in public.

16 Cited in Igor Golomstock, *L'art totalitaire* (Paris: Édition Carré, 1991), p. 66. This is a
key work for the subject we are discussing. Translated from the Russian as *Totalitarian Art:
In the Soviet Union, the Third Reich, Fascist Italy and the People's Republic of China* (Robert
Chandler trans.) (New York: IconEditions, 1990).

RUSSIAN FUTURISTS AND CONSTRUCTIVISTS

Marinetti's first manifesto was immediately translated into Russian and, in January–February 1914, he travelled to Moscow and St Petersburg, where his book *Futurism* had just been published. He received a mixed welcome from Russian Futurists. They had drawn inspiration from his book but their obsession with novelty made it hard for them to acknowledge any indebtedness to the past, no matter how recent that past was. In addition, the Russian Futurists refused to glorify war and they did not aspire to broaden their movement to the social arena, satisfying themselves at the time with an artistic revolution ('Pushkin, Dostoyevsky and Tolstoy should be thrown out of the steamer of modern times,' they proclaimed in their manifesto entitled *A Slap in the Face of Public Taste* [1912]). Nevertheless, Marinetti's conference tour was a success and led to lasting contacts. Malevich compared him to Pablo Picasso for his role in the development of modern art and made favorable references to his ideas until the late 1920s. Vladimir Mayakovsky's meeting with Marinetti in Moscow did not leave an unpleasant impression on the Russian poet. The two men got together again over breakfast in Paris on 20 June 1925. Elsa Triolet (a Russian émigrée, a friend of Mayakovsky, a future writer and yet-to-be wife of Louis Aragon) was there as their interpreter and wondered what 'a Bolshevik and a Fascist' could possibly say to each other. And yet the meeting seems to have been perfectly friendly. In 1923, a fellow Russian writer, who knew they would get along,

wrote in a journal edited by Mayakovsky: 'In Italy, Mayakovsky would have been Marinetti, and in Russia, Marinetti would have been Mayakovsky.'[17]

Avant-garde movements began emerging in Russia around 1910, with abstract art in painting and Futurist inventions in poetry. At first, there was no connection between art and society. On the contrary, painting, for instance, was supposed to detach itself from the material world and obey its own laws— and it did. In 1913, Mikhail Larionov, the painter who founded Rayonism, wrote in his manifesto: 'The objects that we see in life play no role here but that which is the essence of painting itself can be shown here best of all—the combination of color, its saturation [. . .] With this begins the true liberation of painting and its life in accordance only with its own laws, a self-sufficient painting with its own forms, color and timbre.'[18] In 1916, Malevich, who founded Suprematism, declared that painting was to be regarded as 'an act with its own purpose'. To be sure, Kandinsky's abstract paintings maintained a relationship with the real world, since the forms refer to mental categories, just as Malevich's squares, circles and crosses aspire to

17 Jean-Claude Marcadé (ed.), *Présence de F. T. Marinetti* (The Presence of F.T. Marinetti) (Lausanne: L'âge d'homme, 1982), p. 197; Mikhail Levidov, 'O futurizme neobkhodimaya stat'ya' (An indispensible article about Futurism), *LEF* 2 (1923): 135.

18 Mikahil Larionov, *Une avant-garde explosive* (Lausanne: L'âge d'homme, 1978), pp. 72–3; English translation: Mikhail Larionov and Natalya Goncharova, 'Rayonists and Futurists: A Manifesto, 1913', in John E. Bowlt (ed.), *Russian Art of the Avant Garde: Theory and Criticism 1902–1934* (London: Thames and Hudson, 1976), pp. 87–90.

reveal a cosmic order underlying deceptive appearances. Nonetheless, the phenomenal world, the world that is there for all to see, was no longer taken into consideration. At the same time, Marcel Duchamp's readymades made any search for meaning or truth pointless. Similarly, aspiring to free language from its bonds with reality and hence with meaning, the Futurists created a 'transmental' (*zaumnyj*) language. Velimir Khlebnikov advocated 'the autonomous word', meaning 'the word as such', and even 'the letter as such'. In his article 'The Liberation of the Word', Benedikt Livshits wrote: 'Our poetry [. . .] does not place itself in any relationship with the world.'[19]

The separation between art and the visible world of objects or the intelligible world of the senses, and consequently between the search for the absolute in art and in society, was later challenged, sometimes by the very people who had advocated it. At first, this new movement focused on the means used by artists and showed no particular interest in the social order or the political world. The movement was called Constructivism because its adherents took a stand against artistic creation and in favour of the construction of objects and artifacts designed to be part of the surrounding world. Although the first actual Constructivist group exhibition was held in 1921, the embryonic signs of the movement can be traced back to 1915, the year Vladimir Tatlin

19 Kazimir Malewicz, *Ecrits* (Writings), VOL. 1 (Lausanne, L'âge d'homme, 1993), p. 102; Benedikt Livshits, cited in Jean-Claude Marcadé, *L'avant-garde russe 1907–1927* (The Russian avant-garde 1907–1927) (Paris: Flammarion, 1995), p. 6.

showed his 'counter-reliefs' and Malevich unveiled his 'Black Square'. Tatlin's counter-reliefs, made of a variety of materials, were intended not to reveal the essence of the world but solely to highlight the intrinsic quality of the materials.

The opposition between Constructivism and earlier modernist movements was not political in nature: all of them enthusiastically welcomed the oncoming revolution. The difference was in the relationship between the artwork and its social context. According to Boris Arvatov, a later theorist of Constructivism, even when modernist artists retained nothing but the spiritual content of life or its essential elements, as was the case with Kandinsky and Malevich, they 'set art above life and strove to render life in the form of art'. Constructivism, on the other hand, 'set life above art' and privileged function over form, 'not the creation of forms of great "aesthetic" value but their utilitarian construction from basic materials. Not autonomy of the thing as such, but richness of content.'[20]

The great transforming impetus came, once again, out of war and the upheaval it caused. In the wake of the October Revolution, artists belonging to diverse avant-garde movements were immediately co-opted by the new power in Russia. By November 1917, the Bolsheviks had already summoned to Petrograd Futurist artists Vladimir Mayakovsky and Nathan

20 Boris Arvatov, cited in Marcadé, *L'avant-garde russe*, p. 19; Boris Arvatov, 'L'utopie objectalisée' (The objectalized utopia) (1923), cited in Gerard Conio, *Le constructivisme russe* (Russian Constructivism), VOL. 2 (Lausanne: L'âge d'homme, 1987), p. 46.

Altman and theatre director Vsevolod Meyerhold to discuss the role of artists in the new regime. The avant-gardists identified with the revolution. Even those whose agenda had no political content, like the Futurists or Suprematists, were now convinced of the unity of political and artistic movements. 'Cubism and Futurism were revolutionary art movements that anticipated the 1917 revolution in economy and politics,' Malevich wrote in 1919.[21] All of the Futurists, and not only Mayakovsky, welcomed revolution with joy: 'The Futurists were swept into the October Revolution as necessarily as the Volga flows into the Caspian Sea,'[22] one of them declared in 1923. The first high-ranking cultural officials were recruited from Futurist and Constructivist ranks as were those who filled the top positions in the new educational institutions. Projects concocted in small avant-garde journals could suddenly be applied on the scale of an entire country.

Constructivism now aspired to transform the use of all forms of expression. Instead of producing literary works, poets were expected to concentrate on linguistic material for utilitarian purposes. Mayakovsky began to produce political slogans and advertisements. In his autobiography, he defined his group's stance as 'against fiction and aestheticism, for propaganda, qualified journalism and columns'. Indeed, the material used for the

21 Kazimir Malevich, 'Des nouveaux systèmes dans l'art' (New systems in art) in *Écrits* (Paris: Éditions Gérard Lebovici, 1986), p. 336.

22 Levidov, 'O futurizme neobkhodimaya stat'ya', p. 135.

TZVETAN TODOROV

'construction' was not only language; it was also real events evoked by this language. Constructivists preferred 'factual literature', with its source in the author's surroundings, to literature drawn from the imagination. In their conception, art no longer constituted a separate area: everyone could participate in its creation. 'In the Commune, everyone creates,' wrote Ossip Brik, another Constructivist theorist,[23] picking up, perhaps unwittingly, the desire of Novalis, philosopher of Romanticism and a precursor of Wagner, 'for everyone to become an artist and everything to become art'.[24]

Similarly, the aim of visual artists was no longer to produce paintings or sculptures but, rather, to transform the surrounding world through their gestures. Alexander Rodchenko, leader of the Constructivists, was as opposed to easel painting as Mayakovsky was to fiction. 'Non-objective art has left the museums,' he declared during his first exhibition in 1920. 'Non-objective painting is the street itself, the squares, the town and the whole world.'[25] With this in mind, he turned his attention to making posters and drawings for wallpaper and fabric. Existing reality being considered preferable to the imagination, Rodchenko gradually began devoting more time to photography. Similarly, Tatlin went from his counter-reliefs to architectural constructions, such

23 Cited in Conio, *Le constructivisme russe*, VOL. 2, p. 153; Ossip Brik, 'L'Artiste et la Commune', in ibid., VOL. 1, p. 241.

24 Novalis, 'Faith and Love', in Frederick Beiser (ed.), *Early Political Writings of the German Romantics* (Cambridge: Cambridge University Press, 1996), p. 48.

25 Cited in Conio, *Le constructivisme russe*, VOL. 1, p. 44.

as the tower he planned (but never built) as a 'Monument to the Third International'. Architecture was the logical apotheosis of Constructivist experiments: inspired by artistic principles, the architect would fashion the world, building real houses, life-size cities and landscapes.

The performing arts took the same path. Arvatov spoke of 'merging theater with life in Socialist society' as a self-evident development. What form did he think this fusion would take? Staging classic theatre performances or even making them accessible to as many people possible was a thing of the past. The point now was to give shape to life itself: 'rationally construct a way of life'[26] This was how theatre could best fulfil its propaganda functions. In cinema, Dziga Vertov's montage theories participated in the same Constructivist project. Vertov created beautiful works of art without inventing a thing. He filmed what existed and then boldly edited it. In effect, he reorganized the visible world. If you knew how to bring it to the fore, the material itself would act on the viewer. And everything in the world was potential material.

The Constructivist theoretical project was taken to its ultimate extreme by theorist Nikolai Chuzhak when he proposed no less a goal than 'the construction of life'. In articles published in 1923 and 1929 in *LEF* (edited by Mayakovsky), he examined what it meant to make life as a whole benefit from the artistic

26 Boris Arvatov, 'Utopie ou science?' (Utopia or science?) in ibid., VOL. 2, pp. 65–6.

experience. He argued that there were two opposing conceptions of art. In the bourgeois conception, art was 'a method of acquiring a knowledge of life'; in the proletarian, it was 'a method of life-building'. Whereas the first limits itself to representation and to promoting the contemplation of the world, the second sets out to master and transform the materials of life.

We can hear in these thoughts an echo of Marx's famous statement about the status of knowledge: 'The philosophers have only interpreted the world in various ways; the point is to change it.' Now it was the boundary between artist and political activist that was being crossed. The old aesthetic might still be useful as a form of preparation, a 'shy apprentice in the face of the enormously developing life that is being created'. But Chuzhak thought it was time 'to declare war on artistry', on art grounded in the opposition between literature and life. It was time the two were merged. It was time, he suggested, 'to blow up the old junk'.[27] The new art was to be simply one of the methods of life-building. In this the Constructivists made explicit one of the characteristics of all avant-garde movements: this is, their totalizing ambition, the desire to have a valid response for all areas of human life and, in so doing, to exclude all other approaches to the world.

The old aestheticism sought to introduce beauty into life from the outside. The Constructivist set out to change reality by using as a point of departure the materials composing life.

27 Cited in Conio, *Le constructivisme russe*, VOL. 2, pp. 39, 23, 170, 178; English translation: 'Under the Banner of Life-Building (An Attempt to Understand the Art of Today)', *Art In*

'Belles-lettres is opium for the people. The literature of fact is the antidote.' The literature of fact involves picking up and redistributing words that can be heard in everyday life; to start, you have to listen carefully and capture. 'The dance of this life is immeasurably more intricate and complex than the plagiarisms of art!' Chuzhak declared. The writer goes out in search of the world, as an observer and a journalist, and then skilfully puts the pieces together to present a recreated world that better serves the cause of the working class. The wealth of materials is infinite: 'Aren't the minutes of a party meeting, bearing the stamp of majority opinion, as engrossing to read as a novel? Aren't they as valuable in terms of practical effectiveness as a work of art?'[28]

The role of rebuilding must not be reserved to a caste of artists, according to Chuzhak. 'The working of material is not only the destiny of the artist. The masses are becoming keen on the process of creation. [. . .] Art is the business of everyone; art is in the very pores of life itself; life penetrates art, like a very prominent rhythm.' Just as everyone was given the status of an artist, artists were being attributed ever greater importance, since instead of being mere providers of distraction and beautification, they were to become 'masters and directors of the new life'.[29] We have here the rebirth of Wagner's dream.

Translation 1 (2009): 119–51; Karl Marx, 'Theses on Feuerbach'. Available at: www.marxists.org/archive/marx/works/1845/-theses/theses.htm

28 Chuzhak, cited in Conio, *Le constructivisme russe*, VOL. 2, pp. 176, 23, 178.

29 Ibid., p. 180.

At first sight, it seems that art lost the battle when it was pitted against life. Instead of digging down into their imagination, artists now borrowed ready-made materials from the world. Instead of setting works up as objects of disinterested contemplation, they used them for the benefit of society, as though they were being 'commissioned' by society itself. Instead of creating original artifacts, they restricted themselves to focusing on the intrinsic qualities of existing materials and arranging them according to pre-established rules. But this submission was at the same time a victory and the apparent humility was related to a higher ambition: the artist was now seen as a political actor who shaped society, people and individuals according to a pre-established design. Thus, the Constructivist project simultaneously put an end to the life of art and brought it to its apotheosis, because artists were now dealing with human beings and not just words and colours. They were artists, engineers and demiurges all in one. 'The worker of Art must become psycho-engineer, psycho-constructor,' wrote Sergei Tretiakov in the Constructivist journal in 1923.[30] From this standpoint, individuals did not count; all that mattered was the collective destiny.

The euphoria did not last long. The last exhibition of the avant-garde, as it was conceived before and during the war, was

30 Sergei Tretiakov, '*Otkuda i kuda* (*Perspektivu Futurizma*)' (Where from and where to? [Perspectives of Futurism]), *LEF* 1 (1923): 199.

held in 1923. From then on, Mayakovsky, Malevich, Rodchenko and Tatlin were relentlessly criticized by the new cultural bureaucrats whose aim was not to indicate new avenues for society but to dutifully follow party directives. In the struggle to demonstrate faithfulness to the spirit of the revolution, the avant-gardists lost out. Significantly, however, not one of them chose to emigrate. But those who did not become obedient propagandists of the regime were made to suffer—they became victims of the revolution they had sought.

MUSSOLINI, ARTIST AND OEUVRE

There was, in fact, a deep-seated reason for the refusal to let artists play the role of demiurge: this role was to be reserved for the political leaders themselves. The comparison between the artist and the political leader—each working on a different material but from a similar standpoint—had a long tradition behind it; but never before had it been turned into a plan of action. Plato had compared the statesman to the painter: 'No State can be happy which is not designed by artists who imitate the heavenly pattern [. . .] They will begin by taking the state and the manners of men, from which, as from a tablet, they will rub out the picture, and leave a clean surface.' Elsewhere, he compared the legislator to the poet: 'We also are poets of the best and noblest tragedy; for our whole state is an imitation of the best and noblest life, which we affirm to be indeed the very

truth of tragedy.'[31] The German Romantics, drawing inspiration from Platonic conceptions of beauty, picked up this comparison between the statesman and the artist, taking the entire country as their raw material.

However, in Plato, in French revolutionary discourse and in Romanticism alike, the idea of applying artistic creation to society was an image and not a concrete project. Things only changed with the advent of the modern totalitarian state, when the supreme leader had the means to turn these metaphors into literal realities. These totalitarian states were themselves born in a new context. They were ushered in, first, by the accelerated pace of social transformations under the impact of technology, which seemed to afford the possibility of achieving the age-old dream of controlling and transforming nature, and, second, by the sentiment in the wake of the First World War that all laws were revocable and that no form of violence was inadmissible. Once political religions had supplanted traditional beliefs, the ideology that had been formulated by avant-garde movements for several decades began to exert a more or less direct influence on the content of emerging political projects. Henceforth, the transformation of the individual and that of the state could be promoted in parallel as if the new man and the new society were both works of art to be shaped by the supreme leader of the nation.

31 Plato, *République*, 500e–501a and Plato, *Lois*, 817b. English translation: Plato, *The Republic, Book 6* (Benjamin Jowett trans.). Available at: classics.mit.edu//Plato/republic.html; Plato, *Laws, Book 7* (Benjamin Jowett trans.). Available at: classics.mit.edu//Plato/laws.html

The comparison between political action and creative activity appeared very early in Mussolini's thinking. (It's not for nothing that he had been spending time with Marinetti for several years.) In November 1917, Mussolini wrote in *Popolo d'Italia*: 'The Italian people is a mass of precious mineral. A work of art is still possible. One needs a government, a man, a man who has, when it is necessary, the delicate touch of the artist and the hard hand of the warrior.' In 1922, he described himself as the 'sculptor of the Italian nation' and declared that a politician 'works above all with the hardest and most difficult of all materials: man'. Both the sculptor and the politician strive to produce perfect artworks out of a resistant material: in one case, marble; in the other, human beings. His project, as he was wont to explain to anyone who would listen, was to create new Italians, to remake their souls, to shape the masses, to fashion the people as a whole. As he explained to Emil Ludwig several years later, 'everything turns upon one's ability to control the masses like an artist,'[32] and, hence, upon using them as raw material to produce a masterpiece. The means for achieving these aims were as much physical (Mussolini did not object to contemporary eugenist projects) as spiritual. The First World War was a formidable

32 Cited in Marie-Anne Batard-Bonucci and Pierre Milza (eds), *L'homme nouveau dans l'Europe fasciste (1922–1945)* (The new man in Fascist Europe [1922–1945]) (Paris: Fayard, 2004) , p. 7, and in Eric Michaud, *Un art de l'éternité: L'image et le temps du national-socialisme* (An art of eternity: image and time in National Socialism) (Paris: Gallimard, 1996), p. 17; Emil Ludwig, *Talks with Mussolini* (Eden and Cedar Paul trans.) (London: Allen & Unwin, 1932), p. 128.

training ground in this respect: without it the making of the new Fascist man would have been unthinkable. In times of peace, mass organizations, particularly youth groups, were to play an essential role and contribute to turning the entire country into a huge theatre of experimentation on human beings.

Mussolini's project had a distinctly personal tone to it. Not content with being the artisan of the renewal, Il Duce touted himself as the most accomplished product thereof. He was at once the artist and the work of art. The new man he wanted to create was modeled on his own image. In fact, Mussolini started out by fashioning himself as if he were a statue; from humble beginnings he transformed himself, by a deliberate effort of will, so as to appear to his compatriots as a perfect man and an example to follow. He never missed an opportunity to show that he could do the work of a farmer or a labourer, that he excelled at sports, at running, swimming and skiing, and that he could also write philosophical and literary texts. 'The only great artist of the regime at the moment is its founder, Mussolini,' declared an editorialist for *Critica fascista* unequivocally, 'It is clear from all his speeches, political essays and articles that he is the greatest prose-writer of our day.'[33] This was not mere flattery and nor was the comparison between art and politics incidental. A few years later, Ezra Pound wrote: 'I don't believe any estimate of Mussolini will be valid unless it starts from a passion for construction. Treat him

[33] Published 15 February 1927; cited in Batard-Bonucci and Milza, *L'homme nouveau*, p. 82.

as *artifex* and all the details fall into place. Take him as anything save the artist and you will get muddled in contradictions.'[34]

Beyond the ideological proximity of Futurism and Fascism, the latter counted on art to transform society and to make Fascist spectacles worthy of admiration. Foreign observers noted the aesthetic quality of Fascist political action. The French Fascist writer Robert Brasillach described Fascism as 'a kind of poetry, the poetry of the twentieth century (along with Communism, no doubt)'.[35] Particular attention was given to whatever could be turned into a spectacle for the masses: festivals and parades, on the one hand; and architecture on the other, regarded as the supreme art since it concerned all individuals and was there for all to admire. But this aestheticization of political action was never an end in itself; it was always subordinated to the political objective. It was the state, not beauty, that was sacred in Fascism.

It should be noted that, in Il Duce's own eyes, his project ultimately met with failure. He did not succeed in transforming Italians into new men or courageous Fascists. He thought that Italy lost the war for this reason. And he formulated this failure once again in artistic terms. The material was to blame because, as it turned out, it was not hard enough: 'It is the material that

34 Ezra Pound, *Jefferson and/or Mussolini* (London: Stanley Nott, 1935), p. 34.

35 Robert Brasillach, 'Lettre à un soldat de la classe 60' (Letter to a soldier from the class of 60), in *Ecrit à Fresnes* (Written in Fresnes) (Paris: Plon, 1967), p. 140.

is lacking,' he said to Galeazzo Ciano a few months before his death. 'Even Michelangelo needed marble to make his statues. If he had had only clay, he would have merely been a potter.'[36]

HITLER'S ARTISTIC SPIRIT

Adolf Hitler embodied an equally strong relationship between political action and artistic activity but it took on a somewhat different form. It is common knowledge that the Führer reserved a special place for Wagner who incarnated in German-speaking countries the concept of the artist not as a figure among others in society but as the very model for society. As Hermann Rauschning wrote in his book *Conversations with Hitler*: 'Hitler recognized no predecessors—with one exception: Richard Wagner.' This recognition was not an isolated act. On 5 May 1924, in prison following his unsuccessful attempt to seize power, Hitler wrote to Wagner's son, Siegfried, to tell him that his father was 'the spiritual sword with which we are fighting today'.[37] Thereafter, he maintained privileged relations with the residents of Bayreuth.

What was the reason for this dubious privilege? Hitler was enthralled by Wagner's music since his childhood in Austria.

36 Galeazzo conte Ciano, *Diario 1937–1943* (Diaries 1937–1943) (Milan: Rizzoli, 1980), p. 445; cited by Emilio Gentile, *Qu'est-ce que le fascisme?* (What is Fascism?) (Paris: Gallimard, 2004), p. 393.

37 Hermann Rauschning, *The Voice of Destruction: Conversations with Hitler* (New York: G. P. Putnam's Sons, 1940) pp. 228, 255.

Rienzi, in particular, had thrown him into an ecstatic state. But his adoration of Wagner went further. According to August Kubizek, his best friend from that period, 'Adolf sometimes recited by heart [. . .] a letter or a note written by Richard Wagner or he would read aloud from his writings, from *The Artwork of the Future* or *Art and Revolution*.'[38] Hitler claimed to have attended 30–40 performances of *Tristan and Isolde*.

We could read into Hitler's special attachment to *Rienzi* the eventual reason behind his choice of Wagner as sole forerunner —all the more in that Hitler's fondness for this opera from Wagner's youth never waned. Years later, its overture was still being played regularly at Nazi party congresses. And when Hitler went to visit the composer's daughter-in-law, Winifred, in 1939, he spoke again of the effect that his first encounter with this opera had had on him. According to Kubizek who witnessed the scene, Hitler declared: 'In that hour, it began.' Hitler said much the same to another friend (and favorite architect) Albert Speer: 'I myself, as a very young man, while listening to this great music in the theater of Linz, had a vision of a German Reich whose greatness and unity I would engineer.'[39]

38 August Kubizek, *Adolf Hitler: Mein Jugendfreund* (The young Hitler I knew) (Graz-Gottingen: Stocker, 1953), p. 101; cited in Brigitte Hamann, *La Vienne d'Hitler. les années d'apprentissage d'un dictateur* (Hitler's Vienna: the formative years of a dictator) (Paris: Editions des Syrtes, 2001), p. 88.

39 Kubizek, *Adolf Hitler*, p. 343; cited in Hamann, *La Vienne d'Hitler*, p. 77; in Albert Speer, *Journal de Spandau* (Paris: Robert Laffont, 1975), p. 108; and in Eric Michaud, *The Cult of Art in Nazi Germany* (Janet Lloyd trans.) (Stanford: Stanford University Press, 2004), p. 52.

One might think that Hitler's attraction to this opera was mainly determined by its subject matter: how a great orator can lead his people and the dangers he may have to face. But this explanation does not suffice, for Hitler was well acquainted with Wagner's other works and with his texts. Hitler, who longed as a child to be an artist, could not have been indifferent to Wagner's general ideas on the relationship between art and society. What attracted him was precisely the continuity between the two, the possibility of each being a relay for the other. Wagner had abandoned the idea of revolution in the streets to devote himself to the creation of a total work of art, which took the form of opera, but his real goal was still the same: to have an influence on his people and to bring them grandeur and happiness. Hitler, under the impact of war (not revolution), abandoned the practice of painting and, more broadly, his vocation as an artist and creator. If Germany had not lost the war, he declared, 'I'd have become an architect instead of a politician, as great an architect as Michelangelo.'[40] Thus, it was circumstances that led him to strive to produce a work even more 'total' in its nature: the creation of the new German people. Unlike Mussolini, however, Hitler did not present himself as an example of a successful 'work'. In his case, the break between the leader and the masses was even more distinct—Hitler was the artist not the work of art.

40 Cited in Golomstock, *L'art totalitaire*, p. 12.

The comparison between artist and statesman was common in the writings of other Nazi theorists. Goebbels, who considered himself a writer, and hence an artist, picked up Mussolini's metaphor in his novel *Michael* (1929) and described the people as being what stone is to a sculptor—a material to be shaped. Two years later, he reiterated the comparison: 'For us the masses are simply a shapeless material. Only under the hand of the artist can a people be shaped from the masses, and a nation from the people.' In April 1933, when the Nazis were already in power, Goebbels addressed a letter to the conductor Wilhelm Furtwängler, in which he wrote: 'We who are giving form to modern German politics, feel ourselves to be artists entrusted with the lofty responsibility to form from the raw masses a full and solid image of the people.'[41] No work of art could be more total and, at the same time, more ambitious than this. Moreover, it was thought that the best preparation for a statesman was precisely to have practised art. In April 1936, the Nazi party organ, the *Völkischer Beobachter*, published a front-page article entitled 'Art as the Basis of Creative Political Power': 'There is an internal and indissoluble link between the artistic works of the Führer and his great political undertaking,' the author stated. 'His artistic activity [. . .] is the primary condition of his creative idea of the totality.'[42] Hitler could guide the people precisely because he was an artist. It is interesting to note that

41 Joseph Goebbels, 11 April 1933; cited in Michaud, *The Cult of Art*, p. 5
42 Cited in ibid., p. 36.

more than half of the members of Hitler's first government had
artistic backgrounds. In 1937 Goebbels concluded: 'All of
Hitler's work is proof of an artistic spirit. His state is a building
with a truly classic design. The artistic creation of his political
work puts him at the head of all German artists—a position that
is rightfully his because of his character and his nature.'[43]
Wagner's dream was now finally coming true.

What made the artistic model so appealing to politicians?
We have already seen how artists and poets in particular, since
the Romantic revolution, sought to play the part of priests, pic-
turing themselves as guides and educators of the people. Nazi
leaders saw artists as benefiting from a privilege unavailable to
the servants of the old religions: a privilege to freely define their
own aim—and the means to achieve it—instead of having to
obey a book or a legal system not of their own making. This was
the privilege of the genius, the model of all artists, to be able to
break free from rules and create in total liberty. Freedom from
the weight of tradition had become the watchword of avant-
garde movements since the late nineteenth century. Cubists,
Futurists, Dadaist, and abstract painters emphatically asserted
their right to shape the world to their will.

In addition to this freedom, what made the artistic model
so appealing was the actual effect of art on the public. Beyond

43 Cited in Franz Dröge and Michael Müller, *Die Macht der Schönheit, Avangarde und
Faschismus oder die Geburt der Massenkultur* (The power of beauty, avant-garde and Fascism
or the birth of mass culture) (Hamburg: Europäische Verlagsanstalt, 1995), p. 57.

cold reason and logical arguments, art has the power to win people over by acting directly on the senses, on feelings and on the unconscious (a prominent theme of Romanticism that preferred art to science for this very reason). The key advantage of art is that, rather than communicate a message, it transforms the receivers without their knowing. As an unconscious emanation of the spirit of the people, art knows how to find its way back to this wellspring and act on it. This is why Hitler spoke of art so emphatically: 'Art is a sublime mission that demands fanaticism,' was one of his famous statements in this regard; 'art is the sole immortal outcome of human labour' was another. Because art touches everyone, it enabled the Führer to shape the people to his will. Indeed, it was not up to every individual to find one's own way of making life more beautiful according to one's own ideals. Personal interests must be subordinated to general interests and the individual subordinated to the collective, which must, in turn, submit to its leader. Transposed to political life, the artistic model was necessarily inegalitarian since a few select individuals played the role of the artist bound by no constraints, while the masses had to content themselves with playing the part of inert material. As could be expected, a central role was reserved, yet again, for architecture, the total art that could directly transform everyone's life. And the only true artist in this society was the Führer himself, who clearly had no intention of giving free reign to the initiative of artists in the narrow sense of the term.

Consequently, aestheticizing the political, organizing triumphal parades, processions or funerals, and coupling thrilling lighting effects with resounding music was not enough for Hitler. He had to unite politics and aesthetics, bending all institutions and all actions to a single ultimate purpose: the production of a *Volk*, a new people, physically and spiritually. The artist had become a demiurge. 'Anyone who sees National Socialism as merely a political movement knows almost nothing about it,' Hitler said to Rauschning. 'It is even more than religion; it is the determination to create a new man.'[44] This was to be a deliberate action, like that of an artist in a studio or a scientist in a laboratory, but on the scale of the entire country.

The two main means of arriving at this grand creation were propaganda and eugenism. Propaganda could profit from the experience of artists and eugenism would result from scientific progress. Together, art and science would be joined in the service of the Nazi project. The logic behind eugenics involved selecting the best specimens and controlling their reproduction. Thus, the Nazis considered legitimate the elimination of deficient individuals and, ultimately, the extermination of inferior races. Science was no longer content to restrict itself to acquiring knowledge of the world, but sought instead to transform the world, in keeping with Marx's tenet, in order to achieve an ideal that, it claimed, was rigorously deduced from scientific

44 Rauschning, *The Voice of Destruction*, p. 273.

observation. Was this not similar to art? Did not the sculptor hew the shapeless mass of stone or wood and model the clay or plaster to produce a perfect form? This twofold transformation of man, both physical and mental, was in keeping with the project formulated earlier by Marinetti.

What mattered, then, was not so much art in itself (even though Hitler consistently emphasized its exemplary role) as art in the service of life. This is what Hermann von Keyserling, a 'fellow traveller' of Nazism, said in his 1936 speech 'Life is an Art.' Germanic myths and legends, of the kind that informed Wagner's work, were valuable, but it was even more important to enrich the day-to-day lives of German people with a mythical legendary dimension. Everyone would be an artist on one level or another. Work would become creative and utilitarian activities would conform to standards of beauty. The arts were given an extra role besides propaganda: to reinforce the legitimacy of the proposed image of the new man and the new people.

Modern art had influenced the Nazi conception of politics with the image of the artist shaping his material (the human mass), yet it was not the suitable artform for this new objective. And so it came to be regarded as useless (and 'degenerate') and, after some hesitation, the Nazis opted against avant-garde art. Artists were expected not so much to reflect changing forms of life or try to stand out from their immediate predecessors as to

show the persistence of sameness and the conformity of present ideals with past traditions. In practice, in sculpture, painting and architecture, this consisted in promoting not abstract art or the Bauhaus but, rather, a neo-classical and allegorical style, which, to the minds of Hitler and other Nazi leaders, came closest to an eternal canon. The presence of these forms in the past —the ideal human body, as embodied in Greek and Roman sculpture—justified efforts to transform Germans physically through selection and controlled reproduction. Life was to imitate art.

Like Mussolini, Hitler felt, at the end of his life, that he had failed to forge a new people that met his standards. The Germans had lost the war and, for Hitler, victory alone demonstrated the mettle of a people. He would rather have taken this people with him in his act of suicide and wipe them off the face of the earth, but his followers chose to disobey his last words. Neither dictator accomplished his 'artistic' project. The 'work' they did create was of another nature entirely: it was a modern version of hell on earth. The European continent was exposed to unrelenting battles—cities collapsed under bombs, networks of camps imprisoned millions of people condemned to die from exhausting labour, disease, cold and hunger, while millions of others were summarily shot or gassed. The project for new life brought only death.

STALIN, THE ENGINEER OF HUMAN SOULS

Hitler seized power in Germany as a result of the 1932 elections. Around the same time, Joseph Stalin, having defeated his rivals in the Communist Party and consolidated his absolute rule, began turning some attention to the arts in the Soviet Union. Until then, various cliques competed for the right to represent the communist revolution. Stalin put an end to these quarrels by replacing the many different organizations with a single, common centralized union by profession: a writer's union, a painter's union, and so on.

This was also when the expression 'socialist realism' was coined and adopted to define the path of Soviet art. Clearly there was a risk that the two terms of the equation would not always be in agreement since 'realism' seemed to refer to the relationship between representation and reality, and hence to belong to the category of truth, while 'socialist' designated an ideal and consequently the capacity of the work to promote the good. What if truth and goodness—what is and what ought to be—could not be harmoniously combined? What if being realistic did not lead to advocating socialism? Stalin, who liked discussing such issues with writers, could not conceive of such a divide between the two. 'If a writer honestly reflects the truth of life, he cannot but arrive at Marxism,' he declared.[45]

45 Cited in Herman Ermolaev, *Soviet Literary Theories, 1917–1934: The Genesis of Socialist Realism* (Berkeley: University of California Press, 1963), p. 167.

The reason for this indefectible solidarity was provided by Party ideologist Andrei Zhdanov in a speech to the First Congress of Soviet Writers in 1934. Socialism, he argued, was the Soviet future and this future was contained in the seeds of the present. Writers realistically recounting what they saw around them would therefore necessarily include the socialist future. 'Soviet literature must learn how to portray our heroes and project itself into our future. This will not be a utopia, for our future is already being prepared today through a conscious planified effort.'[46] But was this future so certain that it could be described as present? To Zhdanov it was, because he believed that time does not unfold arbitrarily. It obeys not only historical laws but also the will of the Party (as formulated in its plans) and therefore it is perfectly predictable.

Zhdanov reminded the Congress of Stalin's definition of writers as 'engineers of the human soul', formulated during a meeting in 1932. In Russian tradition, great writers were readily attributed the role of intellectual masters and guides. This role would henceforth be assumed by the engineer who would guide the human soul on the basis of scientific knowledge and not craftsmanship. Unlike the Constructivists, who played with the same image (as we have seen with Tretiakov), Stalin left these specialists no room for personal initiative. The party was in charge of the construction. The writer–engineer was a techni-

46 Andrei Zhdanov, *Pervyj vsesojuznyj s'ezd sovetskikh pisatelej* (The first all-USSR congress of Soviet writers) (Moscow, 1934), p. 5.

cian in mental manipulation, present merely to execute orders. The need to observe and describe reality faithfully was not even mentioned. Like the Marxist philosopher, the role of the writer was not so much to interpret the world as to transform it. The works from the 1930s that best complied with this programme were instructional stories about individuals or groups. By describing a promising reality, writers contributed to the advent of the future. Life would imitate art, as the Romantics had hoped. One such work was Nikolai Ostrovsky's *How the Steel Was Tempered*, the story of a man who overcomes blindness and paralysis through his faith in Bolshevism. Another was Anton Makarenko's *The Pedagogical Poem* that tells the story of the virtuous metamorphosis of a group of vagabond children. In this way, instead of aspiring to an absolute of its own, literature was entirely subordinated to Communist Party propaganda as the sole incarnation of the earthly absolute. It is interesting to note, in passing, the persistence of the inorganic metaphor that was emphasized by Marinetti in his time: man was enhanced by metal and machines and likened to steel—the material from which Stalin's nickname was derived (*stal'* for steel).

The other arts underwent a similar fate. They were denied any autonomous objective and, like in Nazi Germany, they borrowed more from the pompous style of nineteenth-century official art than from the revolutionary art of the twentieth century, deemed less effective than the former. Even the most fervent

propagandists, such as Mayakovsky, Meyerhold and Eisenstein, were attacked for not submitting enough to Communist Party directives. As a result, the first committed suicide, the second was shot and the third capitulated.

Stalin was flattering Soviet writers when he called them 'engineers of the human soul'. The true creator, forger of new souls and of a new people, was, of course, Stalin himself, with assistance from his inner circle. The only real artist was the dictator. Here was an artist close to God since his work of art was the entire country and his material was millions of human beings. This is why totalitarian regimes, after having drawn inspiration from the ideas of avant-garde artists, either got rid of them or reduced them to submission. What they needed was not inventors but obedient people to execute orders. 'We shall manufacture intellectuals like products on an assembly line,'[47] proclaimed communist theorist Nikolai Bukharin in a 1925 speech to artists, scientists and writers.

Stalin had clearly integrated the idea of the artist as model. During his studies in the Orthodox seminary, he was an avid reader of the classics of Russian and Western literature. Anton Chekhov and Victor Hugo were among his favorite authors (a fact that should temper expectations that great authors soothe the savage beast). At 17, he himself was an appreciated poet in literary circles in Georgia. He later gave up his artistic activities

47 Cited in Golomstock, *L'art totalitaire*, p. 76.

only because his revolutionary activities took up all his time and energy—the latter replaced the former. By then, he had reinvented himself, becoming his own creation: changing his date of birth (he lopped off a year), finding a new name (Stalin, instead of Jughashvili, was but the last in a long series), and devising roles for himself in political combats. When he reached the summit of power, not only did he take an interest in the great poets and artists of his day, but he also became personally involved in their lives in a perverse game of seduction and brutality. Stalin never lost sight of the relationship between poets and priests. The former seminarian not only incorporated a new cult of saints and icons into Bolshevik ideology but also regarded himself as the inspired pontiff of a supreme will with direct access to absolute truth.[48]

That poets and artists were fascinated by Stalin was no accident. They recognized in him a kindred spirit, acting, in his case, on the immeasurably vaster scale of the world. One of the greatest poets of his day, Boris Pasternak, provides an illustration of this sentiment in his poem 'The Artist' (*Khudozhnik*), published in a journal in Moscow on 1 January 1936. In it, Pasternak contrasts the solitary poet, an individualist who stays at home and examines his soul, with Stalin, the Kremlin recluse, who can make the boldest of dreams come true and who performs daily 'a two-voiced fugue', thanks to 'two extreme

48 Cf. S. S. Montefiori, *Young Stalin* (London: Weidenfeld & Nicolson, 2007).

principles that know everything about each other'—poetry and power. He does not act like everyone else because he is a 'genius of action'—of 'action on a global scale'.[49] What the traditional poet accomplishes in his imagination, Stalin carries out on the scale of world history, changing the course of human destiny. In a letter to Stalin the year before, the poet had written that there was 'something secret that, beyond all that is comprehensible and shared by everyone, [that] connects me to you'. Pasternak was by no means the only artist to experience this fascination. The writer Korney Chukovsky described the effect that Stalin had on a gathering of writers: 'Everyone's face was infatuated, tender, spiritual or laughing. Seeing him—simply seeing him— was happiness for us all.'[50]

As the leader was working on such a vast scale, he did not have time to deal with individual needs and desires. Necessity now took the place of the law—such was the reasoning of totalitarianism. Already in 1917, Bukharin declared: 'Proletarian coercion, in all its forms, from executions to forced labour, is [. . .] the method of molding communist humanity out of the human material of the capitalist period.' Fifteen years later,

49 Olga Ivinskaia, *Mes années avec Pasternak* (My years with Pasternak) (Paris: Fayard, 1978).

50 Korney Chukovsky, *Vlast' i khudozhestvennaja intelligencija* (Power and artistic intelligentsia) (Moscow, 1999), p. 275; Korney Chukovsky, *Dnevnik 1930–1969* (Diaries, 1930–1969) (Moscow, 1994), p. 141. Both are cited in Solomon Volkov, *Shostakovich and Stalin: The Extraordinary Relationship Between the Great Composer and the Brutal Dictator* (New York: Knopf, 2004), pp. 89, 122.

Hitler confided to Rauschning: 'My teaching is hard. Weakness has to be hammered out of them.'[51]

From this standpoint, art, in the strict sense of the term, was just one of the various means available to the artist-dictator —admittedly a particularly effective means, as both communist theorists and Nazi propagandists noted. Another means of action was education; social pressure exerted on families was a third; and information manipulation, a fourth. Since the security organization (successively called Cheka, GPU, NKVD, and KGB) had every imaginable coercive means at its disposal, were they not, ultimately, better 'engineers of the human soul' than writers? One of the foremost Soviet writers, Maxime Gorky, described their agents precisely in these terms: 'The GPU is not only the unsheathed sword of the proletarian dictatorship, it's a school for the re-education of tens and thousands of people who are hostile to us.' After a visit to the gigantic White Sea–Baltic Canal project built by *zeks* from the camps, he described it as a 'miracle of re-education'[52] and welcomed the transformation of men through labour, without giving a second thought to the fact that the bed of the canal was lined with the bodies of

51 'Russian Communist Party Programme', cited in Michel Heller, *La machine et les rouages: la formation de l'homme sovietique* (Cogs in the wheel: the formation of Soviet man) (Paris: Calmann-Lévy, 1985), p. 11; Rauschning, *The Voice of Destruction*, p. 278.

52 Maxim Gorky, *Belomorsko-Baltijskij kanal imeni Stalina. Istoriya stroitel'stva* (The White Sea–Baltic Canal named after Stalin. The History of the Construction) (Moscow, 1934), p. 397. Cited by Michel Heller, 'Maxime Gorki', in Leon Sichler, *Histoire de la littérature russe* (A History of Russian literature) (Paris: A. Dupret, 1886), pp. 78–82.

prisoners. In Russia as in Germany, under totalitarianism, *Arbeit macht frei* . . .

The project of the physical transformation of the human species may not have played as important a role in Communism as in Nazism, but neither was it entirely absent. Traces of it can be found in Leon Trotsky's *Literature and Revolution*, published in Moscow in 1924. In the conclusion, Trotsky—who, like Stalin, had tried his hand at poetry in his youth—tried to imagine what the future socialist state would look like. The boundary between art and industry would be eliminated (everyone would be an artist) as would that between art and nature. Indeed, the man of the future would not simply reshape society—he would transform nature according to his desires. 'The present distribution of mountains and rivers, of fields, of meadows, of steppes, of forests, and of seashores, cannot be considered final,' he wrote. The human demiurge was truly the equal of God: he creates a world to his liking. It was in this context that Trotsky envisaged the transformation of the portion of the universe known as humankind. The task would be entrusted to those who educate individuals and society as a whole. It would be shared by the organizers of communal life. 'The care for food and education, which lies like a millstone on the present-day family, will be removed, and will become the subject of social initiative and of an endless collective creativeness.'[53] In this way,

53 Leon Trotsky, *Literature and Revolution* (Ann Arbor: University of Michigan Press, 1960), pp. 255, 256.

instead of advancing blindly, life in the communist society would be completely planned and controlled.

According to Trotsky, there was an even more radical way of shaping humanity to one's desires—and that was eugenism. There was no reason to be afraid of altering the human species through selection or by acting on the organism itself (what we would call genetic manipulation today) when it was just a matter of adding artificial scientific selection to natural selection:

> The human race will not have ceased to crawl on all fours before God, kings and capital in order later to submit humbly before the dark laws of heredity and a blind sexual selection! Emancipated man will want to attain a greater equilibrium in the work of his organs and a more proportional developing and wearing out of his tissues.

Once man will have mastered his physical transformation, he will 'raise himself to a new plane to create a higher social biological type, or, if you please, a superman'.[54]

Ultimately, Trotsky was removed from power by Stalin and never had the chance to implement these ideas. But the Nazis did. Stalin himself pursued the goal of creating a new man and a new society using more immediately available levers of powers: the state, the party, the police, teachers, writers, and artists. But despite the fact that nothing stood in the way of Stalin implementing his policies for 20 years, until the end of his life in

54 Ibid., pp. 255, 256.

1953, the results were no better than those achieved by Hitler. Victims of Stalin's repression counted in the tens of millions; the rest of the population lived in fear and poverty, and nature itself was thoroughly degraded. The new man that Communism was supposed to produce never existed anywhere outside party slogans and socialist realist novels. The fate of the Soviet state shows that the initial project of eliminating every prior social structure and replacing them by a new order based on science and will inevitably fails. And this was the case not only when its proponents lost the war. Communism was not defeated militarily. It died a 'natural' death. Yet it left behind nothing but material and moral desolation.

AVANT-GARDES AND TOTALITARIANISMS

How are we to interpret this parallel between the ideas and forces that informed both avant-garde artists and totalitarian dictators in the period between the two world wars? Following Walter Benjamin, analysts have often noted that the way in which extremist political movements associated aesthetic and political considerations could fall into two categories: 'the aestheticization of politics practiced by fascism'; and the communist response, which was 'to politicize art'.[55] This famous formulation is unsatisfactory from several standpoints. Firstly, it

55 Walter Benjamin, 'The Work of Art in the Age of Its Technological Reproducibility (Third Version)', in *Selected Writings. Volume 4: 1938–1940* (Howard Eiland and Michael W. Jennings eds) (Cambridge: Belknap Press, 2003), pp. 251–83.

sets up an opposition between the two forms of totalitarianism that subsists only in the eyes of partisans of one or the other. In fact, the aestheticizing tendency existed in Communism just as the inclination to politicize art for propaganda was present in Fascism. Moreover, what we are looking at here is a proximity that cannot be reduced to a matter of one project instrumentalizing the other, and this points to the need to apprehend both projects as emerging from the same womb.

What dictators and avant-garde artists had in common was their radicalness or, if you will, their integrism. Both were determined to create *ex nihilo*, to fashion a work according to their own criteria with no regard for what already existed. Both would have readily adopted Eugène Pottier's call, made famous by *l'Internationale*, to 'make a clean state of the past' ('*du passé faisons table rase*'). And to do so, both employed the same method—revolution. They also had in common a totalizing ambition that knew no limits, stopped at nothing, and admitted no dissension. The artist denied the validity of all other aesthetic canons; the dictator was ready to overturn all anterior norms of social life. Last, what they had in common was a lack of consideration for individual opinions and a preference for standardized collective productions. Faithful to the Promethean project that runs through all of modernity, they set out to create a brand new art, new men, and new nations; in a consistent way, they rejected feminine values—love, affection and compassion—and anything that could come from the outside, be it from nature or

from history. Everything had to be deliberately willed; nothing accepted. The scope of their ambition was infinite, but it defined a closed space because it did not recognize anything outside itself. Intoxicated by their self-importance, artists and dictators were convinced that they could entirely master the process of construction—be it of works of art or of societies.

What made them different from each other was, above all, the scale on which they worked: the entire country, with its entire population, in the case of the dictator; a book, a painting, a stage, a house, a street, or a district at most, in the case of the artist. Of course, the dictator was alone in experiencing this identification of his activity with artistic creation. The compliant masses, be they in Stalin's Russia, Hitler's Germany, or Mussolini's Italy, did not perceive the fusion between political and artistic activity and had no idea that their existence was being shaped to conform to a canon of beauty. The absolute to which their state subjected them and which they were supposed to venerate, had another face altogether and it formed a collective, not an individual, ideal. This new god was called the nation or the state in Fascist Italy, the people in Nazi Germany, and Communism in Soviet Russia, and its ministers took up its service in the ranks of the party. The average citizens in these states were not given the leisure to shape their lives like works of art according to their own conception of beauty; they were compelled to conform to the common ideal. While the dictator was experiencing a fusion between the two modern forms of the

absolute, the political and the artistic, the population was force-fully subjected to the political absolute—the revolution, the party, and the leader, with beauty relegated to a very subordinate role. What they saw was something altogether different: death by millions, persecution, imprisonment, submission, fear, and moral depravity.

Individual artists cannot be held responsible for the totali-tarian turn of events to which they themselves often fell victim (this restriction does not apply to activists like Marinetti or Mayakovsky). But it is important to draw attention to the extent of their political naivety and to note the risk involved in formulating extremist theories in the field of art, forgetting the sinister reality which they may one day give rise to. We have here a telling example of something that intellectuals and artists forget all too often—namely, that words and pictures are also acts that have ramifications in the life of a society. The expres-sive power of artists carries with it a greater political responsi-bility. The avant-garde movements may not have been the sole source of totalitarian doctrines, but the role they played in the development of the latter cannot be ignored. Let us be remind-ed in this regard of Simone Weil's warning during the Second World War:

> I believe in the responsibility of writers of recent years for the
> disaster of our time. [. . .] The essential characteristic of the
> first half of the twentieth century is the growing weakness,
> and almost the disappearance, of the idea of value. [. . .]

Dadaism and surrealism are extreme cases: they represented the intoxication of total licence, the intoxication in which the mind wallows when it has made a clean sweep of value and surrendered to the immediate.[56]

The similarity between the Romantic project and political revolutionary aims also suggests a much deeper relationship between the two, one that can be traced back to their origins in the nineteenth century. Consciously or not, Romantic thinkers adopted a Manichaean view of the world, with artists and poets forming the elite of humanity and art playing the role reserved for gnosis in ancient religious doctrines. The same was true of utopian thinkers, who dreamed of the collective salvation of humankind as a whole or of a particular people. This convergence can be found in the avant-garde metaphor, which was used to describe both clairvoyant artists and the party in the forefront of the fight, and opposed, in both cases, to the passive masses destined to meekly follow their lead. Political and aesthetic Manichaeanism may clash in certain circumstances; they nonetheless share a similar worldview. The champions of totalitarian doctrines may have been contemptuous of Romantic thinkers and Romantic thinkers may have turned their back on political engagement, but they participated, however, in the same historical movement. Karl Popper, who was keenly aware

56 Simone Weil, 'Lettre aux *Cahiers du Sud* sur les responsabilités de la littérature', *Les Cahiers du Sud* 34 (1951): 426–30. Letter probably written in the summer of 1941. English translation: 'The Responsibility of Writers', *On Science, Necessity, and the Love of God* (Richard Rees ed. and trans.) (London: Oxford University Press, 1968), pp. 166–9.

of the resemblance between political and aesthetic forms of extremism, concluded his analysis of the origins of totalitarianism, saying that both aestheticism and radicalism share an attitude that 'springs from an intoxication with dreams of a beautiful world that I call Romanticism'.[57]

We know only too well the damage that was caused by the temptation to implement a total revolution when the ideal was political in nature. The utopian projects that professed to replace a mediocre present with a radiant future became the totalitarian systems of the twentieth century and their remedy was far worse than the illness they proposed to cure. We now spurn peddlers of political dreams—utopians who promise us that happiness is just around the corner—because we have learned that promises such as these served in the past to hide the sinister designs of Lenin, Stalin, Mussolini and Hitler. But we tend to see Romantic images, in their artistic perfection, as the antithesis of this. In reality, this is simply not the case. It was not merely a matter of interaction or rivalry between the two; they proceeded from the same conception of the world, informed by the belief that they possessed the recipe for a supreme creation that had no need to burden itself with previous ways of living and creating. They both set up a radical antithesis between low and high, present and future, evil and good, and sought to eliminate the first term of each opposition definitively. The problem

57 Karl Popper, *The Open Society and Its Enemies*, VOL. 1 (Princeton: Princeton University Press, 1971), p. 135.

is that once the ideal ceases to be a distant horizon and becomes the rule of everyday life, the result is disastrous. What ensues is the reign of terror. History teaches us that the dream of Romanticism, though evidently less deadly than political utopianism, was equally treacherous in nature.

ART AND ETHICS

All Western writers who have given any thought to poetry, literature or the arts for the past 2,500 years have discussed the relationship of these practices to morality, arguing for or against it, so there is every reason for me to feel somewhat intimidated by the idea of taking a new look at the subject today. And although I have no intention, of course, of retracing in this context the entire history of debates on the subject, neither can I act as if I were the first to take it up. Therefore, I've chosen a middle path. I will start with an extremely schematic outline of this history (comprising manifest simplifications), for the sole purpose of focusing attention on otherwise imperceptible lines of force, just as a bird's-eye view will sometimes show contours of buildings that no longer exist and that are indiscernible from the ground. This rather distant approach to examining the development of a

series of ideas seems all the more appropriate to me here inasmuch as it highlights a major break in this history that took place in the eighteenth century. I will be concentrating hereafter primarily on the case of literature.

Classical Dogma

One could say that, since the origins of theory on art and poetry in ancient Greece and until the Age of Enlightenment, the different responses to the question that engages us here were all situated within the same framework. Writers on the subject have asserted the necessity and dignity of morality, their respect for virtues and their condemnation of vices, and consequently deemed poetry and art to be either totally futile and hence unworthy of praise or acceptable only insofar as they live up to certain moral standards. A discordant voice may have made itself heard from time to time, but this view of the relationship between art and morality met with approval from the vast majority of authors. I thus label it the 'classical' theory regarding this relationship. And, from this perspective, the function of an 'ethical criticism' is self-evident: it assesses the qualities of each work with respect to the ethical principles prevalent in contemporary society.

Without going into details, I would like to illustrate this classical theory with a few examples. Plato in *The Republic* (*c*.360 BCE), as we may recall, sees little value in poetry, since poets only know how to produce imitations (or representations). Hence, he

proposes to banish them from the city. This is an extreme position even for Plato who elsewhere (in *The Laws*, for instance) assumes a different attitude and acknowledges that poets and artists can contribute to the education of the young as long as they rigorously follow the instructions of their superiors, the guardians of moral principles. In the words of Plato's spokesman:

> Shall we make a law that the poet shall compose nothing contrary to the ideas of the lawful, or just, or beautiful, or good, which are allowed in the state? Nor shall he be permitted to communicate his compositions to any private individuals, until he shall have shown them to the appointed judges and the guardians of the law, and they are satisfied with them.

Here, Plato had already envisaged the institutions needed to impose this conception, institutions with which we are very familiar from recent history and which we—as moderns, attached to our civil liberties—find shocking, since we are speaking about organs of censorship and even political police. The poet has no choice in the matter. 'The true legislator will persuade, and, if he cannot persuade, will compel the poet,' even to the point of specifying the content of the work, for 'you compel your poets to say that the good man, if he be temperate and just, is fortunate and happy.'[1]

Plato's successors were not nearly as drastic but they nonetheless agreed that poetry and art must serve morality, be it

1 Plato, *Laws, Book 2* (Benjamin Jowett trans.). Available at: classics.mit.edu//Plato/laws.html

by purging passions or by other means. The purpose of art was to 'delight and instruct', as Horace put it in *The Epistle to the Pisones* or the *Ars Poetica* (*c*.18 BC). This maxim, which was to achieve long-standing success, associates utility and pleasure in a manner conveniently non-specific enough so as not to overly regulate poetic activity. But the utility criterion gained strength with the advent of Christianity, when poetry was appreciated solely as an instrument of moral edification. Dante described his own *Comedy* as moral philosophy, and Boccaccio maintained that the fables of poets, properly understood, are moral in every respect. During the Renaissance, Scaliger's poetics reaffirmed Horace's principle. And in seventeenth-century France, the criterion became the foundation of classical aesthetics which specified the relationship between Horace's two terms as follows: 'The purpose of poetry is utility,' wrote Jean Chapelain, 'even though it is obtained by pleasurable means.'[2] Molière, La Fontaine, Racine and Boileau would have agreed wholeheartedly.

Even though this doctrine was to be increasingly contested in the course of the eighteenth century, it still found many advocates. Among them, Denis Diderot must have been one of the last major figures and he applied the principle to all literary genres. Thus, dramatic composition must 'inspire in men the love of virtue and the horror of vice', and novels must 'elevate the mind [. . .] and be inspired throughout with love of the

2 Cited in Rene Bray, *Formation de la doctrine classique* (The making of the classic doctrine) (Paris: Librairie Nizet, 1966), p. 70.

good'. The same holds true for painting and sculpture: 'To make virtue desirable, vice odious, and ridicule apparent—that is the aim of any honest man who takes up pen, brush or chisel.'[3]

Amid this massive consensus, that one suspects at times to be but a front, a few rare discordant voices emerged, contending that while poetry must, of course, continue to please and delight, it did not lend itself well to instruction. Yet this, they thought, was no reason to banish it from the city—affording pleasure was a practice they deemed worthy of respect. Their conceptions of art were essentially hedonistic, maintaining as they did that art was precious even though it served no purpose. 'Poetry was invented purely for pleasure and distraction,' Lodovico Castelvetro declared in the second half of the sixteenth century. François Malherbe, some time later, stated that 'a good poet is no more useful to the state than a good skittles player'. And Pierre Corneille, a century later, had this to say about poets: 'As long as they have found the means to please, they have fulfilled their obligation to their art.'[4] Not only were such opinions in the minority but they also endorsed the classic conceptual framework of utility. All that was set aside was the claim that poetry had a moral role.

3 Denis Diderot, *Dorval et moi* (Dorval and me), VOL. III (1757); *Eloge de Richardson* (Tribute to Richardson) (1762); and *Essai sur la peinture* (Essay on painting) (1765). Cited in Philippe Van Tiegheim, *Les grandes doctrines littéraires en France* (The great literary doctrines in France) (Paris: PUF, 1968), pp. 116–17.

4 Bray, *Formation de la doctrine*, pp. 65, 71; Van Tiegheim, *Les grandes doctrines*, p. 14.

Modern Dogma

Nonetheless, in the eighteenth century, a genuine revolution was in the making which, to put it briefly, comprised rejecting the subordination of art to morality not because it served it poorly but because it had another purpose—namely, to embody beauty. And beauty—herein lay the innovation—was not only not necessarily there to serve an outside moral agency, it was defined precisely by the absence of all such utility. The difference with regard to hedonistic conceptions is immediately apparent. It is not that art *can* not serve morality (or education or the good) but that it *must* not. This revolution did not proceed from a new way of thinking about art but was the outcome of a wide-ranging transformation, at once ideological and social, a transformation designated by such terms as secularization and democratization. What was being challenged was the dominant hierarchical position held by religious discourse that had served as both foundation of and yardstick for public life. *Heteronomy* (law from elsewhere) was being replaced by *autonomy*. Gradually religion was losing its grip on knowledge (autonomy of science), morality (that had to find human not divine justifications) and political power (sovereignty of the people). This radical change was accompanied, in the field of art, by a socio-economic one, embedded in the same logic that was challenging the hierarchies. Until then, artists depended primarily on sponsors and patrons to demarcate the destination of artworks—the royal court, the aristocracy and the high orders of the Church. But from this

point on, artists began to create mainly for the public. The success of a work of art depended on audiences filling the theatre, on amateurs buying paintings or commissioning portraits, on readers buying books. The market imposes a tyranny all its own, without doubt, but it has no moral content.

One could describe in detail the stages in this global transformation along with the different forms it assumed in the different arts or in the specific traditions of each country. I will confine myself here to singling out a few significant moments.

As Meyer Howard Abrams has shown in several studies,[5] the first steps in this direction were taken by Shaftesbury at the very beginning of the century. According to Abrams, Shaftesbury is responsible for transposing the Christian idea of God into the profane idea of beauty—a transposition not particularly disturbing to him since he regarded truth, goodness and beauty as one. Saint Augustine had divided all human deeds into two groups of very unequal scope: all objects on Earth may be *used* (to achieve other purposes) but God may only be *enjoyed*. God is the ultimate purpose. Shaftesbury would all the more easily translocate this definition of the divine into the secular because Augustine, 1,300 years earlier, had transposed Plato's definition of the highest good into a description of the attitude to adopt towards God. Shaftesbury described the

5 See, in particular, his 'Kant and the Theology of Art', *Notre-Dame English Journal* 13 (1981): 75–106; and *Doing Things with Texts* (New York: Norton, 1989).

perception of beautiful works of art as an act 'where there is no possession, no enjoyment or reward, but barely seeing and admiring'—a form of utterly disinterested perception which he called *contemplation.*

The work of art thus prompts an attitude of love that resembles the attitude that the Ancients thought should be adopted in friendship—when friends are appreciated with no regard for profit, when they are loved for themselves. An attitude that resembles, according to Christian writers, that of pure love for God, a selfless love that expects nothing—no services and no rewards. This type of love, Shaftesbury continues, aims 'at what is called disinterestedness, or teaching the love of God or virtue for God or virtue's sake'. The main characteristic of aesthetic judgement will be, in turn, its disinterestedness. Far from considering aesthetic contemplation an inferior activity, incapable of serving sublime purposes, Shaftesbury likens it to what is most elevated—God or the sovereign good—precisely because beauty, too, is unfit for serving any other purpose and finds its justification in itself.

Skipping several intermediary stages, we can stop for a moment on Gotthold Ephraim Lessing's *Laocoön* (1766), which presents a shift from a description of aesthetic contemplation to a description of the aesthetic object itself (the artwork) and the process of its creation. Characterized by the absence of an external purpose, and hence by a radical refusal to be subjected to

religious or moral objectives, both the process and the product abide by the standards of beauty alone. According to Lessing:

> I could wish that the title of work of art were assigned only to those in which the sculptor appears in his true character as an artist, and in which the delineation of beauty has been from first to last the object of his labors. All those works, on the contrary, which bear too obvious marks of having served the purposes of worship, are undeserving of that title; for in such cases art was employed, not for its own sake, but as an aid to religion, whose object in the representations she demanded was rather the significant than the beautiful.[6]

For Lessing too, it was not a matter of belittling art but of declaring it unsuited to the role of serving morality. Its role is, rather, to embody beauty—which is better.

One more link in the elaboration of this new theoretical approach deserves to be mentioned and that is the work of Karl Philipp Moritz, a marginal but prophetic writer in many respects. One of his early essays, 'On the Unification of All the Fine Arts under the Concept of the Complete-in-Itself' (1785), stands as a veritable manifesto. Not content with rejecting utility as the purpose of art, Moritz went to great lengths to separate himself from those who, like Castelvetro and Corneille, considered art's goal to be to please or produce pleasure. This for him appeared to be too external a goal. Pure beauty, like pure

6 Gotthold Ephraim Lessing, *Laocoön; or The Limits of Poetry and Painting* (William Ross trans.) (London: J. Ridgeway & Sons, 1836), p. 104.

love, and like God once again, finds justification in itself and
not in the satisfaction that others (creators or consumers) draw
from it. 'Pleasure in the beautiful must therefore ever approxi-
mate to disinterested *love*, if it is to be genuine.'[7] Not only must
it not be useful but henceforth it would be defined by the
eschewal of utility. It is that which is 'complete-in-itself', that
which needs nothing else. Beauty in its turn becomes the only
rule for the construction of a work of art. But Moritz compen-
sates for the absence of external purpose by what he calls 'inter-
nal purposefulness'—an arrangement of all of the parts of a
work so that we perceive every one of them as absolutely neces-
sary, thereby contributing to the making of this totality, 'com-
plete-in-itself', which is the work of art.

Kant does not dwell long on the description of artworks in
his *Critique of Judgment* (1790) but concentrates first and fore-
most on the judgements we pass on beauty, be it natural or arti-
ficial. The examples he keeps in mind are of flowers or decorative
drawings as they appear on wallpaper. His interest lies primarily
in the intermediary status, so to speak, of these judgements, since
they are neither objective, like those of science, nor purely
subjective, and this leads him to formulate an original theory of
intersubjectivity. But Kant does not innovate as far as the char-
acteristics of beauty are concerned and merely picks up ideas—
notably Christian ideas of pure love and Plato's idea of sovereign

7 Cited in Abrams, *Doing Things with Texts*, p. 166.

good—formulated throughout the eighteenth century by writers ranging from Shaftesbury to Moritz. The aesthetic experience is necessarily disinterested. Not subjected to any requirement from the true or the good (it is 'concept-free'), it is thus self-sufficient. The work of art has no purpose, even if its form gives us the impression of one (Moritz's 'internal purposefulness'). Integrated into Kant's overall system of thought, the impact of these ideas on subsequent aesthetic thinking and art theory was to prove enormous.

A new dogma thus came to replace the precedent one, the one I termed 'classical'. In this context, and for the sake of commodity, it may be called the 'modern' dogma. It was adopted by the early theorists of Romanticism, the Schlegel brothers and Novalis, and spread from their writings to other European countries, in particular to England and France. It even crossed the Atlantic, and we find a particularly aggressive version of it a few years later, penned by Edgar Allan Poe who described the prerequisite of making poetry serve morality as 'a heresy too palpably false to be long tolerated [. . .] the heresy of *The Didactic*'—a fatal forgetting of the fact that the poem must remain its own end.[8] The declaration swiftly crossed back to France where Charles Baudelaire—later the translator and promoter of Poe's ideas—spoke in his turn of 'the heresy of

8 Edgar Allan Poe, 'The Poetic Principle', *Essays and Reviews* (New York: The Library of America, 1984), p. 75ff.

didacticism' and asserted that the sole purpose of poetry was the poem itself. 'Poetry,' according to Baudelaire, 'cannot, except at the price of death or decay, assume the mantle of science or morality'[9] and it was with him that the doctrine of art for the sake of art would henceforth be associated. Nearer to the end of the century, Oscar Wilde wrote in the preface to *The Portrait of Dorian Gray*: 'There is no such thing as a moral or immoral book. Books are well written or poorly written. That is all.' And he concluded: 'All art is quite useless.'[10] Countless other writers and theorists produced variations on this basic doctrine, which remains, it seems, the dominant paradigm to this day—even though it allows for many exceptions.

Doubts

However, in contradiction to what the rabbit tells Alice, simply repeating a thesis will not make it true. Ultimately, modern dogma's assertion that the artwork is self-sufficient, even autotelic (meaning that it finds its purpose in itself), is no more satisfying than the classical theory that artworks must promote morality. To be sure, there are didactic and moralizing works that correspond to the latter definition, as there are works of pure entertainment unrelated to the rest of the world that correspond to the former.

9 Charles Baudelaire, 'Notes nouvelles sur Edgar Poe' (New notes on Edgar Poe) in *Œuvres complètes* (Complete works), VOL. 2 (Paris: Gallimard, 1976), p. 333.

10 Oscar Wilde, *The Picture of Dorian Gray* (Charleston, SC: BiblioBazaar, 2007), pp. 7–8.

But, in the end, neither category is what makes most of humanity love and respect art. Are we really forced to choose between conceptions that form the basis of Socialist Realism and those that underpin Oulipo?[11] As Abrams says in the conclusion to his study of the modern dogma: 'When we turn to *King Lear*, or Michangelo's *Pieta*, or Beethoven's *Ninth Symphony*, or Picasso's *Guernica*, the concepts of art-as-such are patently inadequate to account for the range of our responses to these works, which implicate our knowledge and convictions about the world, our moral interests, and our deepest human concerns.'[12] The fact that the classical and modern theories could prevail so strongly over our representations of art can tell us a lot about the systems of thought of which they are part but it does not give us a better understanding of the nature of art itself.

Besides, even the strongest advocates of modern theory had some difficulties with the brutal elimination of whatever did not contribute to the contemplation of beauty, and they ended up more or less surreptitiously reintroducing previously rejected elements albeit without giving them a clear status. Moritz admitted that the experience of the recipient of an artwork could be taken into consideration but only as a consequence and not as the purpose of the work. Benjamin Constant, the first to have used the French expression '*l'art pour l'art*—'art for art's sake'—

11 A French literary movement founded in 1960 that worked on the basis of formal constraints.—Trans.

12 Abrams, 'Kant and the Theology of Art', *Doing Things with Texts*, p. 101.

later commented that 'instruction is the effect not the goal of painting,'[13] thus leaving the window partially open to the figure he'd just thrust out the door. And although Baudelaire argued that poetry must not be subjected to morality, he was referring to a morality imposed from the outside since, to his mind, poetry harbours within itself a higher morality. Once the 'official morality', the external purpose, was eschewed, the 'real morality', inherent in art and superior to the other, would prevail. In a letter to Narcisse Désiré Ancelle, written towards the end of his life, Baudelaire admits that *Les Fleurs du mal* expresses all his convictions and feelings, and, he adds: 'It is true that I will write the opposite, that I will swear on all the gods that this is a book of *pure art, monkey business* and *tomfoolery*. And I'll by lying through my teeth.'[14] Wilde himself qualified his radical statements—the lack of an external purpose characterizes not so much the artwork as the creative process. At the time of writing (or painting or composing), artists must worry only about the perfection of the work itself and not about the effect it may have or the lesson it may impart. Somewhat enigmatically, Wilde also declared that to him literature was 'the first thing of life, the mode by which perfection could be realised'[15]—hardly the same thing as declaring it perfectly useless!

13 Benjamin Constant, 'Réflexions sur la tragédie' (Reflections on tragedy) in *Œuvres* (Complete works) (Paris: Gallimard, 1979), p. 920.

14 Letter of 18 February 1866, in Charles Baudelaire, *Correspondance*, VOL. 2 (Paris: Gallimard, 1973), p. 376.

15 Oscar Wilde, 'To the Home Secretary, 2 July 1896', in *The Complete Letters* (Merlin Holland and Rupert Hart-Davis eds) (New York: Henry Holt and Co., 2000), p. 657.

Kant makes several suggestions along the same lines in his *Critique of Judgment*. Fine art, he writes 'is a mode of representation whose purpose is found in itself but which [. . .] although devoid of an end, has the effect of advancing the culture of the mental powers in the interests of social communication.' Poetry ranks highest among the arts because 'it expands the mind by giving freedom to the imagination',[16] and this expansion of the mind that enabled human beings to identify with each other was considered by Kant to be the vocation of the human species. Thanks to the artist's imagination, Kant suggests, we can contemplate and judge nature from points of view to which our own individual experience do not give us access. Kant does not explain how this essential function of poetry relates to its self-sufficient and autotelic character. Nonetheless, we can take this as the starting point in our attempt to gain a better understanding of the relationship between art and morality.

Even if we accept the idea that an aesthetic judgement about the beauty of a work of art must be disinterested, this would only describe a small part of the process of receiving the work in question. Similarly, when artists create a work and are unconcerned with its effect, they too, in a sense, are disinterested. But this purely negative way of describing the artist's experience clearly does not suffice to give us an accurate picture of the process. Disinterestedness appears at another point in Kant's

16 Immanuel Kant, *Critique of Judgment* (James Creed Meredith and J. H. Bernard trans.) (London: Macmillan, 1914), p. 44, 53.

theoretical philosophy, namely in reference to human acts which, to be moral and to serve the greater common good, must be disinterested. Here 'interest' rhymes with self-interest and hence with selfishness, and the disinterested act serves to overcome it. Creative artists are encouraged in turn to free themselves from the grips of self-interest. What are they to replace it with? Love of beauty, say the Moderns, a love modelled on the pure love for God. But a different hypothesis may be formulated: great art demands that self-love be replaced by a certain form of love for the world. The 'world' is to be understood here in its totality, but in the case of literature it is clear that we are speaking essentially of the human world.

It was a later Romantic, Rainer Maria Rilke, who found the most eloquent terms to describe the obligation that the artist may feel to love the world in order to create. In letters written to his wife Clara in Paris, in the fall of 1907, he spells out his way of understanding the creative work of Paul Cézanne and Auguste Rodin, Charles Baudelaire and Gustave Flaubert. It is not that artists must paint or describe their love and appreciation of the world but that they must actually love the things themselves in order to understand and recreate them. What happens then is what Rilke characterizes as a 'consuming of love' in the work of art. The true artist 'knew how to repress his love for each single apple and to store it in a painted apple forever'. True artists do not subject the world to their tastes—they subject themselves to the world. 'The creator,' writes Rilke, 'is no more allowed to discrim-

inate than he is to turn away from anything that exists.' To evoke
the artist's 'pure love' directed not to God or to beauty but to the
world, Rilke turns to the figure of Saint Julien l'Hospitalier, as
described by Flaubert. 'This lying down beside the leper and shar-
ing with him all his own warmth, even to the heart-warmth of
nights of love: this must sometime have been in the existence of
an artist, as something overcome toward his new blessedness.'[17]
Now, the question is: If one loves in this way the world and the
beings that people it, can this act still be entirely alien to the idea
of the good?

IRIS MURDOCH'S HYPOTHESIS

This nexus of questions is given an enlightening perspective in
the writings of English novelist and philosopher Iris Murdoch.
In a series of texts written between the late 1950s and the late
1970s, Murdoch engaged in a conversation on these subjects
with some illustrious predecessors—notably Plato and Kant but
also Rilke—in a way that helped articulate her conception of the
relationships between art and morality. A programmatic formu-
lation of her thoughts may be found in a 1959 text: 'Art and
morals are [. . .] one. Their essence is the same. The essence of
both of them is love. Love is the perception of individuals. Love
is the extremely difficult realisation that something other than

17 Letters of 13 October 1907 and of 19 October 1907, in Rainer Maria Rilke, *Letters of
Rainer Maria Rilke 1892–1910* (Jane Bannard Greene and M. D. Herter Norton trans.)
(New York: W. W. Norton & Co, 1945), pp. 311, 315.

oneself is real. Love, and so art and morals, is the discovery of reality.'[18] These abrupt statements call for comment.

Murdoch's starting point is the fundamental psychological fact of our egocentricity and the selfishness that results. We think of ourselves spontaneously as the centre of the world and the inevitable discovery that the outside world exists independently of us and that we are as insignificant as a particle of dust lost in the cosmos is painful to us. We protect ourselves against the pain caused by this discovery with a 'cloud of more or less fantastic reverie',[19] a part of which works directly to glorify and console the self, while another part works indirectly to relate the self to the collective fictions and mythical and religious stories that surround us. These practices manage skilfully to avert any obstacles that we may be tempted to set up in their path. Thus, engaging in a search for self-knowledge is another form of self-indulgence, as Catholic confessors know well; similarly, 'the ideas of guilt and punishment can be the most subtle tool of the ingenious self'.[20]

But self-concern is not the only force that moves us and we experience at the same time a curiosity towards the world around us; we are, more specifically, drawn to other human beings without whom we cannot exist nor find satisfaction (Murdoch does not dwell on the nature of these other forces). This other impetus

18 Iris Murdoch, 'The Sublime and the Good', in *Existentialists and Mystics: Writings on Philosophy and Literature* (Peter Conradi ed.) (New York: Penguin Books, 1999), p. 215.

19 Iris Murdoch, 'The Sovereignty of Good Over Other Concepts', in ibid., p. 364.

20 Iris Murdoch, 'On "God" and "Good"', in ibid., p. 355.

costs us—we neglect ourselves as a result—but it enriches us too. Artistic creation is precisely one of the forms taken by this urge that counters our obsessional self-preoccupation. To make an artwork, one has to practice an acceptance of the world and this acceptance begins with tolerance, continues with attentiveness and respect and culminates in love—a love devoid of the selfish desire for possession.

Diametrically opposed to a certain Romantic image of artists using their work as expressions of the self, Murdoch posits that great art involves removing the self to make room for the world and its discovery. What makes art is 'a loving respect for a reality other than oneself'. The artist's worst enemy is self-complacency. The good novelist (as Mikhail Bakhtin noted) is the one whose characters cannot be reduced to him/herself—they are, on the contrary, capable of acting as free agents. 'Art is not an expresion of personality, it is a question rather of the continual expelling of oneself from the matter at hand.'[21] Respect for the world is what allows this self-withdrawal.

Now, if the artwork evidences an expelling of the creator's self in favour of the world and of other human beings at the same time as it invites its consumer—the reader, viewer or listener—to do likewise, then it is plain to see that art and beauty are not dissociated from morality. The artist accomplishes a

21 Murdoch, 'The Sublime and the Good', p. 218; Iris Murdoch, 'The Sublime and the Beautiful Revisited', in *Existentialists and Mystics*, p. 283.

moral act by devoting him/herself to a knowledge of the world and to its represenation. Both art and morality are 'disinterested', as Kant understood. But we could go a step further—both imply a lack of 'self-interest' that is compensated by an interest in, even a love for, other human beings and the rest of the world. This does not mean that artists cannot be subjects of their works but that, when they are, they are explored as parts of the world.

And it is not only beauty and the good that are indissolubly linked—the search for truth is also engaged in the same process. If I give priority to the world over myself, I make knowing the world possible. At the same time, seeking truth is a moral act in its own right since the self has to give up its prerogatives for this purpose. The truth to which art aspires cannot be measured by the same instruments that we use to evaluate the work of physicists or even of historians, because we cannot objectify this knowledge in the same way. Alongside the referential truth must be placed the intersubjective truth, for artistic views can only be validated by the support of other human beings. And the criterion for this validation, as Kant already observed, though 'weak indeed and scarce sufficient', can be found 'in the universal communicability of the sensation [. . .], in the accord, so far as possible, of all ages and nations as to this feeling'.[22] But it is not because it is difficult to measure that this truth does not exist.

22 Kant, *Critique of Judgement*, p. 17.

Recognizing that others exist as fully as myself is at once an act of knowledge acquisition (this is true) and a moral act (this is good). The great work of art bears witness to the moral effort that was needed to bring it to the light of day at the same time as it furthers knowledge. 'Prose literature can *reveal* an aspect of the world which no other art can reveal [. . .]. And in the case of the novel, the most important thing to be revealed [. . .] is that other people exist.'[23] The writer's horizon is truth—not sincerity—hence priority must be given to the world over the self. Artistic creation has thus an intrinsic moral dimension, which depends not on the more or less virtuous message that the work addresses to us but on the exigent nature of the demands that the artist addresses to him/herself. This dimension may remain unconscious, even denied, and it can run counter to the artist's explicit declarations. The love of the world, necessary for the creation of a great work of art, must be distinguished from the message intended by the author which may be one of hate for the world or other human beings. And, of course, this morality need not be formulated within the work; from the perspective of our contemporaries, it is even preferable that it is not. It is nonetheless true that it remains inscribed in the artwork where it can be found by its recipients.

Obviously, one can give priority to the world over oneself and seek to know the world without engaging in the production

23 Murdoch, 'The Sublime and the Beautiful Revisited', pp. 281–2.

of works of art. But, in the course of daily life, gestures of love and the quest for truth get entangled with other realities, including with self-promotion and contempt for the rest of the world. Love itself can weaken or become tainted with lust. The privilege of the work of art is to embody this impetus in a concentrated form and with a density that is lacking in the rest of life. This is why art is not merely a source of pleasure or an enjoyable distraction but something worthy of respect. 'Art indeed, so far from being a playful diversion of the human race, is the place of its most fundamental insight.'[24] And literature, from this standpoint, is the richest form of art because its material is the very words upon which human existence depends. Contrary to Plato, we will say that the fact that poetry is a representation is a strength and not a weakness, for a successful representation presupposes love of the world and we are always in need of this virtue.

DIFFERENCES IN PURPOSE

Let us take a closer look at the meaning taken on here by these two fundamental concepts of 'morality' and 'art'. To assert their kinship, Murdoch relies on the presence of a single common feature: the consciousness of a reality outside the self, and hence the ability to get beyond self-centredness. But is the lack of self-centredness necessarily altruism? A distinction needs to be made. To become conscious, with mindfulness and even love, of the

24 Murdoch, 'On "God" and "Good" ', p. 360

existence of matter outside myself is not a question of morality in the common sense of the term. A craftsperson who makes a good chair, a mason who builds an upright wall, is not accomplishing a moral act, even though each must have a knowledge of the objective properties of wood or stone. A well-constructed wall, as George Orwell used to say, is not praiseworthy if it serves to enclose a concentration camp. There are no moral deeds outside the human world, and then only when they are beneficial to nonselves. After all, we know countless cases in which becoming conscious of the existence of others and getting to know them well is simply a way of subjugating them and exploiting them better. For there to be a moral act, Emmanuel Lévinas writes, one must 'give priority to the other over the self'.[25]

Not all art has the same relationship to the human world. Musical creation, for instance, requires no particular attention to humanity and relies instead on the intimate knowledge of music itself. Therefore we have to add another specification here—the parallel between art and morality is valid only if art takes human beings as its subject matter. This is the case mainly for literature (because the medium of language itself is exclusively human) and figurative painting, especially when it considers human life to be its theme.

These initial distinctions do not suffice. What we call 'literature' consists of countless works written with the most varied

25 Emmanuel Lévinas, *Entre nous: Essais sur la penser-à-lautre* (Between us: Thinking of the other) (Paris: Grasset, 1991), p. 119.

intentions and leading to an infinite diversity of experiences. No definition or description can hope to apply a single criterion that will embrace this variety in a satisfactory way. Although Murdoch's criterion is no exception to the rule, it manages to identify a feature of literature that we intuitively recognize as central. This being said, it is important to add that this has not been the case throughout time and in all traditions. This hypothesis corresponds to a view of art born in the Renaissance, reinforced in the eighteenth century and shared today by certain types of authors and readers—certainly not by all. Moreover, it is clear that all artworks do not fulfil the stated criterion to the same degree. The reader may have noticed that in presenting Murdoch's views (and my own related thoughts) I have been brought, following Murdoch, to use such adjectives as 'great', 'good' or 'true' to qualify the nouns 'art', 'literature', 'artist'. To maintain the general hypothesis, we would have to exclude certain practices from the confines of art, which are commonly associated with it, and admit that certain works or genres come closer to this ideal than others. I will confine myself here to indicating a few key alternatives.

The first distinction that must be drawn concerns the purpose of creative activity. Not all works are produced with an eye to acquiring a loving knowledge of the world, and not all artists share Saint Julien l'Hospitalier's readiness to lie beside lepers. Up to a certain period in history, as we have noted, such a view of art would have been considered heretical since art was intended to

serve an external morality. Nearly the opposite has become true for us today. Artworks that stand as dutiful illustrations of one doctrine or another hardly deserve to be qualified as artistic, or, at any rate, cannot aspire to the category of 'great art'. We would categorize them instead as a form of sermon or propaganda.

The purpose of such works is not to grasp the truth of the world but to give us a lesson. This may be moral in nature but the difference is great between this morality and that inherent in the artistic creation. The interest in the world is subservient to an interest of a foreign nature (a dogma). The imposed morality destroys the morality inherent in the artistic gesture, and love of the real world no longer plays a decisive role. Reducing the artwork to an illustration of a thesis runs counter to the demand for truth and submission to reality in yet another sense, since it deprives readers or viewers of the freedom to search for the meaning of the work for themselves. The world is complex and great works of art possess an ambiguity that recreates this complexity instead of submitting it to a dogma. I should add, however, that what is clearly separated in theory is not always in actual fact, and deciding to what category a work belongs can sometimes be the subject of lengthy discussions (Sergei Eisenstein's films being a case in point).

Another difference in purpose separates art from entertainment. This distinction aims to set apart two structures rather than hierarchize works of art. The one purports to reveal the

truth about reality, while the other is intent on gaining public approval. If we are to believe what Rousseau writes in the *Letter to D'Alembert on the Theatre* (finished in 1758), the majority of plays being shown on Parisian stages at the time had entertainment as their sole objective, which means that, contrary to the pretensions of theorists, 'delight' (to use Horace's term again) had already won a decisive victory over 'instruction'. How could it be otherwise, Rousseau asks, since the staging of a play is dependent on public success alone? Hence economic changes caused a change in aesthetic choices. Shows must entertain or else disappear. And entertainment has nothing to do with exploring the mysteries of the world but everything to do with providing audiences with what they love most. Instead of 'faithfully presenting the true relation of things', the poet is tempted to 'accommodate them to the taste of the public'. Advocates of 'instruction' haven't a chance—the theatres where they stage their plays risk remaining empty. 'One might as well go to a sermon'—lovers of morality do not spend time in theatres. 'An author who would brave the general taste would soon write for himself alone.'[26] If this is really the case, then authors cannot be considered the true source of their works since they are forced to write according to the dictates of the public.

We have the impression that Rousseau is painting a rather realistic picture of the theatre in his day, one significantly less

26 Jean-Jacques Rousseau, *Politics and the Arts: Letter to M. D'Alembert on the Theatre* (Allan Bloom trans.) (New York: The Free Press, 1960), pp. 27, 47, 19.

virtuous than advocates of the 'classical' dogma pretend. What is more, his description is prophetic insofar as it applies even more aptly to artistic practices in the following centuries, when a 'mass culture', subject to the standards of entertainment alone, emerged and became an economically dominant force. Paul Valéry identified this phenomenon when he wrote, before the Second World War, 'of works that are created, so to speak, by their audiences, whose expectations they meet and which are therefore determined by knowing them'.[27]

In a still more recent past, the pressure exerted by the public on the content of artworks grew even stronger as a result of technological developments. First of all, instead of people going out to a show, the show was brought into their homes—in the form of a rectangular object called a television set. Its main effect was to send soaring the number of spectators. Instead of several thousand watching, now there were millions, even tens of millions. These viewers also had a swift and direct means of acting on programme content—they could simply switch from one channel to another. Audience ratings translate viewer expectations into numbers. Since the income of television stations depends, via advertising, on the number of spectators, these ratings dictate content and style in a way that is considerably more tyrannical than moral and religious organizations in the past. The impact of these statistics is such that it determines not only the

27 Paul Valéry, *Oeuvres*, VOL. 1 (Paris: Gallimard, 1959), p. 1442.

content of the shows but also the positions of political leaders. Viewer reactions and polls measure public responses to every one of their moves. They know at any given moment whether or not their decisions are liked; when they are not, they risk losing their positions the next time elections are due. This is how the idea of success has come to replace ideals and values.

Yet, Rousseau's criticism was also excessive. Many shows in his day were informed by the desire not so much to please the audience as to communicate some sort of truth about the human condition. The same was true in Valéry's times and again in our day. Entertainment is omnipresent and its impact is enormous but it does not dominate everything. Most writers (since their creative work does not require huge investments!) are not following recipes for success; they are, rather, driven by an inner need, possessed by the desire to understand and reveal a facet of the world, a brand new experience. In countries that aspire to protect both individual freedom and collective interests, art has not been submerged by entertainment any more than it has been made to serve the ends of propaganda.

Lastly, we should mention another possible tendency with regard to the purpose of creative activity, even though its impact is comparably less significant than that of entertainment or propaganda. Rather than aspiring to know the world around us better, particularly the human world, the goal of some artists is to *deconstruct* it, if we can take this term in a more radical sense than it is usually given in critical debates. In literature, this

deconstruction firstly targets the narrative and it becomes impossible to recreate the story. It continues by attacking the characters, absent or incoherent, and it culminates in a deconstruction of meaning, a refusal to situate the elements of the text in relation to one another. But the fact is that individual identity, story and meaning are not marginal features of the human world—they are, on the contrary, fundamental properties thereof. To repudiate them is to relinquish trying to know the world. This is perfectly legitimate as a personal exploration but more worrisome as a sign of the spirit of the times. As Romain Gary wrote in a striking shortcut (knowing full well that the historical sequence was, of course, the opposite): 'It starts with the elimination of characters from novels and it ends with the slaughter of six millions Jews.'[28]

DIFFERENCES IN GENRE AND CONTENT

The principle of recognition and love that Murdoch deems indispensable to a successful representation of the world is not adhered to in the same way by the different literary genres. The most relevant distinction is not between prose and verse or between poetry, drama and epic, but between two major modes of construction that are sometimes called the lyrical and the narrative. The two differ from one another like the singular and the plural. The lyrical text features a single consciousness, that of the

28 Romain Gary, *Pour Sganarelle* (For Sganarelle) (Paris: Gallimard, 1965), p. 159.

subject (the poet), and it is situated in an indeterminate present; rather than relating a story, it has a certain affinity with sapiential books (or wisdom literature). The narrative text brings to life several characters, each existing in an autonomous way, and several points in time, presenting, as it does, a temporal unfolding. Needless to say, intermediary or mixed cases abound but the modes themselves are clearly separate. The narrative text corresponds more closely to Murdoch's definition since its subject is necessarily the human world (whereas a description of nature cannot in itself constitute a narrative, it can be the subject of a lyrical poem); human plurality and diversity is its starting point.

On the other hand, the choice between fictive and historical characters (or deeds) seems to be of no significance. Many contemporary authors practice a genre situated between the two—they take the real world as their subject matter, keep people's true names and respect the sequence of events as they could have been recorded by an historian or a journalist. And yet they explore their characters' inner world like novelists, trying to understand the hidden motives of their acts.

The case is somewhat different for the distinction between novel and autobiography. Here it is not that one presents real people and events and the other does not but that the one focuses on the book's author and the other puts the person of the author aside and sets out to explore the world. To be sure, insight into specifically human behaviour is always acquired with the help of

an instrument that is unique to each person and that is shaped by that person's past experience. Nevertheless the choice of the self as support for the narrative is conducive to the kind of comforting self-gratifying reveries from which Murdoch hoped to free us. It is conducive but not determining, as is evidenced by the many remarkable autobiographies that testify to a capacity to stand back from the self, make it part of the outside world and subject it to a lucid examination.

What we are seeing here is a difference that is a matter of content and not genre. Not all books that evoke the human world manifest a passionate desire to understand it better and represent it in all its bounty. Many merely extend and develop the initial self-absorption, eventually broadening it to the group to which the individual belongs. In *The Tale-Tellers* (2008), Nancy Huston calls the type of narrative that results, and that is perhaps the most prevalent, the 'Ur-text'. ' "You are one of us. The others are the enemy." This is the archaic, all-powerful Ur-text of the human species.'[29] This narrative overlays two oppositions—us and them on the one hand and the good and the bad on the other—according to a Manichaean structure that aims at protecting and reinforcing our egocentric and ethnocentric tendencies.

This message, which can hardly be said to be the product of a disinterested love for the world, is reiterated in innumerable narratives, from the ancient epics to the films we see on television

29 Nancy Huston, *The Tale-Tellers* (Toronto: McArthur & Company, 2008), p. 74.

or at the cinema. They claim that we are the strongest, the bravest of heroes, the embodiment of superior values; or, if we've been vanquished, that we are innocent victims deserving of reparation. They claim that the others are evil through and through, that they are cruel, savage and monstrous and that we should have nothing but contempt and hate for them and that, for this reason, all means are acceptable in our fight against them. Even the use of torture has been unreservedly promoted all too recently on the television series *24*.

Yet, since antiquity, the opposite has also been practised. Homer's *Iliad* does not divide the world between good and bad; and Hegel deemed Sophocles' *Antigone* the greatest masterpiece of all time precisely because the play exemplifies the human complexity that constitutes the substance of tragedy. 'The heroes of Greek classical tragedy are confronted by circumstances in which, after firmly identifying themselves with the one ethical "pathos" which alone corresponds to their own already established nature, they necessarily come into conflict with the opposite but equally justified ethical power.'[30]

As a genre, the novel encourages transcending Manichaean worldviews. It emerged in the seventeenth and eighteenth centuries, at a time when moral and ideological certitudes were weakening and when the range of choices and individual liberties were growing. The emancipation from theological dogmas

30 G. W. F. Hegel, *Aesthetics: Lectures on Fine Art* (T. M. Knox trans.) (Oxford: Oxford University Press, 1972), p. 1226.

that defined good and evil once and for all, the abandonment of paradisiacal and infernal imagery and their replacement by scenes that could come from the reader's daily life, the attention given to representing a plurality of minds and not bombarding readers with a moral message at the end of the book—all these conditions made of the novel a particularly well-adapted instrument for exploring human complexity. Once again, this does not mean to say that there are no egocentric Manichaean novels. But this criterion enables us to make a motivated judgement about the value of works.

LIMITS

Accordingly, works of art do not reveal to the same degree the truth of the world nor evidence the same love for reality that enables self-effacement before alterity. What's more, it is well-nigh impossible to draw conclusions from the truth and virtue of a work of art as to the truthfulness and virtue of its author or its readers. This must be stressed—the experience I am trying to apprehend and describe here is lodged in the artwork itself.

The fact that a great work of art may be deemed as constituting a moral act does not mean that its author is virtuous. Such an inference is impossible, for the individual is not a monolithic block but, rather, a stage on which different roles are played out, simultaneously or successively. An actor's performance can be described as particularly true to life, or remarkably revealing of the depths of the human being, but we know at the

same time that when the show is over he or she will abandon their roles on stage and assume others in life: the drinking companion, the irritable mother or father, the capricious lover and so on. We are not surprised that they do not exemplify the qualities of their stage performance in their everyday lives.

From this standpoint, writers are not very different from actors. They too can be wholly devoted to the search for truth in their work and they too can give us examples of a love for the real world that makes them give priority to it over themselves. But when they step out of this role they can be all the more selfish with their family and friends precisely because they have the impression that they have already satisfied the obligations of generosity. As Murdoch notes, 'We are admittedly specialised creatures where morality is concerned and merit in one area does not seem to garantee merit in another. The good artist is not necessarily wise at home, and the concentration camp guard can be a kindly father.'[31] Artists give to the maximum extent in the works they produce; one should not look for the same intensity elsewhere in their lives. One will not find the humanity that radiates from Rembrandt's paintings in his relationship with his mistresses. Often this disparity is reproduced in the work itself, when the message that is produced by the quality of workmanship exceeds or contradicts what the author deliberately puts in the mouths of his characters.

31 Iris Murdoch, *The Sovereignty of Good* (London: Routledge, 1970), p. 94.

The relationship between the virtue of a book and the virtuousness of its readers is even more problematical. In recent decades, several American authors have drawn attention to the relationship between art and morality, arguing for the relevance of 'ethical criticism'. In so doing, they have sometimes ill-advisedly crossed the boundary between the work and the effects it has on its readers. Wayne Booth maintains that in reading we are 'inescapably caught up in ethical activity'; Martha Nussbaum writes that 'our own attention to [the] characters will itself, if we read well, be a high case of moral attention'; and, according to Noël Carroll, '[r]eading a novel [. . .] is itself generally a moral activity'.[32] Admittedly, confronted with the beings that people works of fiction, each reader is invited to expand his/her own being, as Kant suggested. But, in reality, this transition is overly dependent on the condition designated by the clause 'if we read well'. There is nothing automatic about the moral improvement of readers. Firstly because, as we have seen, not all books, not even all novels, are anywhere near to evidencing virtue at the time of their writing—a great number of them fit more readily into the category of the Manichaean Ur-text. Further, if the impact of books is as significant as advocates of 'ethical criticism'

32 Wayne Booth, 'Why Banning Ethical Criticism is a Serious Mistake', *Philosophy and Literature* 22 (1998): 374; Martha Nussbaum, 'Exactly and Responsibly: A Defense of Ethical Criticism', ibid.: 344; Noël Carroll, 'Art, Narrative, and Moral Understanding', in J. Levinson (ed.), *Aesthetics and Ethics* (Cambridge: Cambridge University Press, 1998), p. 145. All cited in Joshua Landy, 'A Nation of Madame Bovarys: On the Possibility and Desirability of Moral Improvement Through Fiction', in Garry L. Hagberg (ed.), *Art and Ethical Criticism: New Directions in Aesthetics* (Oxford: Blackwell, 2008), pp. 63–94.

suppose, these effects are just as likely to be harmful as beneficial. Finally, even the greatest of books can be the object of lazy, indifferent or perverse readings which obstruct the moral improvement of the reader.

In addition, people can read in a completely different vein than the one posited by these theorists. Rather than finding in the book the revelation of an unknown piece of the inner or outer world or a way of opening up to other human beings, readers have every right to simply draw pleasure from how well-crafted the work is or to make it the starting point of their own personal reflections.

One may even wonder whether the vicarious virtue experienced during reading has the effect at times of dispensing readers from the need to exemplify it in the rest of their lives. This is the hypothesis Rousseau develops in *The Letter to d'Alembert*. According to him, moral judgement is, in general, innate but it cannot be freely exercised unless the subject is not concerned, for selfishness too is innate and more powerful than the sense of justice. 'The heart of man is always right concerning that which has no personal relation to himself,'[33] he writes in a statement that La Rochefoucauld could have penned; elsewhere, he states that we are all 'able to support the misfortunes of others'.[34] We go to the theatre and have no trouble being virtuously stirred

33 Rousseau, *Letter to d'Alembert*, p. 24.
34 Ibid., p. 39.

without that emotion having any impact on our behaviour elsewhere; in fact, the one experience dispenses us from the other. 'In giving our tears to these fictions, we have satisfied all the rights of humanity without having to give anything more of ourselves,' Rousseau concludes.[35] Spectators are only too pleased with themselves—they have discharged their duty and, moved by their own generosity and courage, they feel no more of an obligation than the actors to continue doing as much once the show is over. They too are playing a role.

Thus Murdoch's thesis calls to be reframed within a series of restrictions and limitations. The artistic act is also an ethical act and an act of knowledge, but what is true of the work is not necessarily true of its author or of the reader. Some literary or artistic genres lend themselves better to this act than others, and not all works meet this criterion to the same extent—in fact, some purposely reject it. What we are dealing with here is not therefore purely a descriptive point of view but, rather, the hypothetical foundation upon which stand the judgements of value that enable us to recognize great works of art. From this same point of view, it is not appropriate to practice a purely historical (or 'realistic') criticism concerned with the accuracy of the work, and a second strictly ethical form of criticism based on its morality and a third concerned with its formal perfection alone. As Murdoch writes: 'The relation of art to truth and

35 Ibid., p. 25.

goodness must be the fundamental concern of any serious criticism of it. "Beauty" cannot be discussed "by itself". There is in this sense no "pure aesthetic" viewpoint.'[36] If one accepts the stipulations and specifications formulated here, one can admit that literary critics have but one function—to elucidate the meaning of the work, a meaning that simultaneously convokes its cognitive, ethical and aesthetic dimensions. In sum, critics need not be qualified by an adjective—they simply need to be, thoroughly, critical.

36 Iris Murdoch, 'The Fire and the Sun: Why Plato Banished the Artists', in *Existentialists and Mystics*, p. 449.

Acknowledgements

I would like to express my gratitude to the following people: Mike Abrams, for several conversations around these themes, the latest of which dates to 1997; Joshua Landy, whose personal commentaries and article, cited here, were of great assistance to me; and Rob Zaretsky, who attracted my attention to the writings of Iris Murdoch—whom I had met in January 1988, at a time when I had not yet read a single line of her work.

74 - Oleg
31 - 23 - Terry - more from
Peterson
87 - Ⓚ
95 - Ⓚ - Rinaldo-(2)